The Oxford Literary Review

Volume 32 Number 2 2010

Edinburgh University Press

Oxford Literary Review **Subscription rates for 2011**
Two issues per year, published in July and December.

		UK	Rest of World	N. America
Institutions	Print	£81.00	£86.00	$159.00
	Online	£73.00	£73.00	$135.00
	Print and online	£101.00	£108.00	$199.00
	Back issue/ single copies	£42.00	£44.00	$81.00
Individuals	Print	£32.50	£35.00	$64.00
	Online	£32.50	£32.50	$60.00
	Print and online	£40.50	£44.00	$81.00
	Back issue/ single copies	£18.00	£19.00	$35.00

Postage
Print only and print plus online prices include packaging and airmail for subscribers in North America. Print only and print plus online subscriptions for subscribers in the Rest of the world include packaging and surface mail postage. Please add a further £6 if you would like your subscription posted by airmail.

Payment options
All orders must be accompanied by the correct payment. You can pay by cheque in Pound Sterling or US Dollars, bank transfer, Direct Debt or Credit/Debit Card. The individual rate applies only when a subscription is paid for with a personal cheque, credit card or bank transfer from a personal account.

To order using the online subscription form, please visit www.eupjournals.com/olr/page/subscribe

To place your order by credit card, phone +44 (0)131 650 6207, fax on +44 (0)131 662 3286 or email journals@eup.ed.ac.uk. Don't forget to include the expiry date of your card, the security number (three digits on the reverse of the card) and the address that the card is registered to.

Cheques must be made payable to Edinburgh University Press Ltd. Sterling cheques must be drawn on a UK bank account.

If you would like to pay by bank transfer or Direct Debit, contact us at journals@eup.ed.ac.uk and we will provide instructions.

Advertising
Advertisements are welcomed and rates are available on request, or by consulting our website at www.eupjournals.com. Advertisers should send their enquiries to the Journals Marketing Manager at the address above.

Transferred to digital print 2013

The Oxford Literary Review

Volume 32 | 2010

The Truth in Photography

Book Reviews

Snapshot

Michael Naas

> (Photo: impuissance à dire ce qui est évident. Naissance de
> la littérature.)
>
> —Roland Barthes, *Journal de deuil*

In a 1973 episode of the TV series *Kung Fu* the itinerant priest Caine
(played by David Carradine) befriends a young girl (played by an
eleven-year-old Jodie Foster) who ends up accusing him of murder.
Witness to a stagecoach robbery, the young girl, hiding behind a well,
believes she sees Caine taking part in the crime and shooting one of
the stagecoach drivers. Encouraged by everyone, including Caine, to
'tell the truth', that is, the truth about what she *believes* she saw, the
young girl replays the scene in her mind — a series of freeze frames or
photographic snapshots (Caine being tossed a gun, Caine holding the
gun, a man being shot, Caine throwing the gun to the ground) — and
concludes from these discrete memory images that, contrary to what
she believes in her heart, her new found friend did indeed shoot the
stagecoach driver.

As she sees Caine being led to the gallows, however, the young girl
comes to regret having helped convict her friend with what she believed
to be the truth. She thus recants her testimony, says she saw nothing,
and saves Caine with what she knows to be a lie. Though she cannot get
the 'truth straight in her head' (the snapshots in her memory continue
to show her that Caine did it), she somehow, as Caine puts it, got it
'straight in her heart'.

The Oxford Literary Review 32.2 (2010): v–vii
Edinburgh University Press
DOI: 10.3366/E0305149810000738
© The Oxford Literary Review
www.eupjournals.com/olr

The episode ends — it's American television after all — by leaning rather heavily on the moral that we should never tell a lie and that with the first lie comes our loss of innocence, even though, as we will have just witnessed, lies sometimes save lives and are sometimes more 'true' than what one believes to be the truth. But the title of the episode alone, which is also the first name of the young girl, promises something more — even though it is American television — something more complex about the relationship between truth and untruth, memory and forgetting, visibility and concealment. Here is how the girl introduces herself to Caine in the beginning of the episode as the camera captures her emerging from behind a tree, 'they call me Lethe, but my real name is Miss Alethea Patricia Ingram'. And here is how Caine at the very end of the episode reveals to Alethea the truth of her own name: 'The people of the country of Greece have a name for truth — Aletheia. Aletheia is a girl who loves the truth'.

Rest assured, this issue on *The Truth in Photography* has nothing to do with *Kung Fu*, or even television more generally. Though the 'Alethea' episode of *Kung Fu* plays with photography, perspective and framing in some rather interesting ways and includes many allusions to vision (eye-patches, a masked hangman, Caine's 'Chinaman' eyes, Alethea's squinting eyes, and so on), the episode takes place in the Old West and so has no references to photography strictly speaking. And yet this curious little episode (viewable today on Youtube) captures in a snapshot, if you will, many of the themes and questions at the center of this issue of the *OLR*: the relationship between photography and memory, photography and testimony, evidence, narrative and truth, photography and a kind of truth that goes beyond historical reality and what was or can be visible, the relationship between revelation and concealment, even the relationship between East and West in their respective understandings of photography and truth, indeed even the notion of Truth — Alethea (or Aletheia) — as a young girl, whether she hails from Greece, the Old West, or, as we will see, Japan.

What Caine tries to get Alethea Patricia Ingram to understand is that there is a truth in excess of memory, a truth that is somehow concealed by, but only accessible through, the photographic snapshots of perception and memory. Every article in this issue attempts in its own way to think this excess through the works of Roland Barthes, Walter Benjamin, Hélène Cixous, Jacques Derrida, Julia Kristeva,

Siegfried Kracauer, among many others. Thus Andrew Benjamin, reflecting on some of Kracauer's work on photography, asks not only about the truth in photography but about the nature of photography itself in its relationship to a time and a reality that would be in excess of the past and of history. Elaine Miller uses Goethe's notion of the primal or Ur-phenomenon to rethink what Walter Benjamin understood by the 'optical unconscious', and she goes on to argue that Kristeva's analyses of the irruptive force of the semiotic might give us some clues about how to think this 'unconscious' in photography. Elissa Marder demonstrates through a reading of Hélène Cixous's *So Close* and Roland Barthes's *Camera Lucida* that what she calls the 'photographic maternal' bears witness through an uncanny form of 'déjà vu' to an unphotographable event or a 'utopian' past (comparable to Proust's involuntary memory) that was never present as such but is nonetheless very real.

The issue concludes with 'Melville's Couvade', an original piece of fiction by David Farrell Krell that has at its center or on its centerfold a series of reflections on photography and a series of photographs of that place of which Freud will have said 'there is no other place of which one can say with so much certainty that one has already been there.' Finally, the issue opens (like a shutter) with a previously untranslated essay by Jacques Derrida on photography. In this relatively brief but powerful essay, Derrida considers the relationship between shadow and light, concealment and unconcealment, truth and untruth, in a series of black and white photographs by the Japanese photographer Kishin Shinoyama of the famous model Shinobu Otake, a young woman whom Derrida risks calling in the middle of his essay — after deferring and veiling her name for several pages — 'Aletheia'.

Aletheia

Jacques Derrida

Keywords: truth, Aletheia, Japan, photography, Kishin Shinoyama.

The photographer left; he told the truth.[1]

It is she.

She remains without witness, save an invisible witness to attest that there is no more witness.

We left; it is as if the two of us were dead, the photographer as well, after having spoken the truth — spoken without seeing [*voir*], without knowing [*savoir*], and without being able [*pouvoir*]. It is as if she were dead, buried alive in the flowered crown of her wedding dress. But she remains and she will have shown her name, on the verge of more than one language. It is (the) truth and she comes to us from Japan.

'*Light of the dark?*' What does that mean? We wonder about this before opening the work. Then while looking at it, thus while reading it, we wonder about it again, after the fact. And the question resonates *in* the very body of the images, right on the captive body of these images. It is borne like a child; it comes to the lips of this young woman who nevertheless remains silent and exposes herself in silence to silence. But what is a word, then? What is a name?

Indeed, this great photographic work does not say a word. It remains silent, to be sure, and apparently it is content to tacitly show a scene of silence: a young woman *exposes herself* to the light and to the eye. She even seems for an instant to expose herself to death like a virgin, a fiancée, a wife, a mother between day and night, but without ever speaking. And yet, the work, already from its English

The Oxford Literary Review 32.2 (2010): 169–188
Edinburgh University Press
DOI: 10.3366/E030514981000074X
© The Oxford Literary Review
www.eupjournals.com/olr

title, makes us think language; it even promises to touch upon the body of the word in the play of tongues. It animates a tongue that conceals itself before the camera; it lays bare its movements, which are at once indecisive, incomplete, innocent, and perverse. Imminence of the tongue or of language. There is in fact only imminence in this photographic narrative where everything is sketched out, announced, and seems to *prepare itself* (for all the events of life: love, marriage, birth, death, their cyclical, thus reversible and thus ahistorical order, and thus in defiance of all narration) but nothing seems to come to pass from these preparations [*préparatifs*]. Words come. *Light.*² Perhaps it is an adjective: *light* [*léger*] (how does one say *light* [*léger*] in Japanese?). This young woman is the very lightness of an image body. Nothing is lighter than an image; the image of heaviness has no weight. Like all images, *this one*, this image, this woman comes from the night and returns to it without waiting, as if to her native element. She divides and shares herself between night and day; she says without words the sharing of light and shade. She is born there and she dies there, borne by the night like the lightest of simulacra. Now, because she *exposes* — others would say *proposes* — her nudity to the gaze, even to the voyeur and to the potential mercantilism that always accompanies spectacle, curiosity, optical prostheses, and technical reproduction, the lightness of this image is also appropriate for what one calls in French *une femme 'légère,'* that is, a 'loose' woman (play of modesty and seduction, coquetry, perverse science and venal sublimity of someone who knows how to hold *herself* and to keep hold of the other, on the verge of desire and pleasure, though she's on the verge of tears, in the dealings of the marketplace, where charm itself, and the appeal of pleasure or profit, ignites the movement of merchandise, greed as much as gratitude: the dark soul of lightness [*la légèreté*]).Twilights: just as the noun *the dark** can, at the break of day, *name*, thus *call* the night, obscurity, invisibility, shadow, the dark continent of sex, the unknown of death, non-knowledge, be it learned ignorance but also the hidden eye of the camera (beneath its black veil like in the beginning of the century or today its coffin-box [*boitier-cerceuil*]), and as an adjective *dark** can describe all that, by metonymy, darkly conceals itself from the light and resists being seen; so in what is more than an opposition, *light** (which is preceded by no article in the title and could be an attribute or a subject, an epithet or a noun) comes to signify *light* [*léger*], certainly,

but also the day, the light, and the visibility of the phenomenon (*light, the daylight**).

Now it is also what, discreetly, in seeming to exhibit *something else*, the work *shows* and the allegory allows to be understood: light itself, the appearance or genesis of *phōs*, light. This young woman is herself, certainly, unique and very singularly herself, but she is also light [*la lumière*]: (the light [*légère*] allegory of) light [*lumière*] hides itself, she holds herself in reserve, between parentheses, in something else, that is, in shadow. She thus signifies. She signifies what the clarity of the day will have been, yesterday, the day before: the written archive, the graphic memory of this birth of light to *photographic* light, that which at once captures, inscribes, and keeps visibility imprinted. *Photography* as *skiagraphy*, the writing of light as the writing of shade. In the shadow of this shadow, how not to think of Junichiro Tanizaki? His *In Praise of Shadows*[3] in 1933 evoked a 'national genius' that 'already reveals itself in photography'.[4] Likewise in cinema, with 'the same equipment', the 'same developing chemicals', the 'same film', the Japanese do not write like the Americans, the French or the Germans do. They play otherwise with shadows; they calculate differently, we could say here, with the idiom of light in shadow. Tanizaki also declared that 'the Westerner' 'has never pierced the enigma of the shadow',[5] that 'the intrinsic obscurity of the Nō and the beauty that emerges from it form a singular world of shadows that in our day we see only on the stage'.[6] And the already scandalous author of *A Fool's Love* [*L'amour d'un idiot*] (1924)[7] also recalls the preference of his ancestors for a woman 'inseparable from darkness [*l'obscurité*]' whom they 'tried hard to immerse entirely in the shadows'.[8]

The filming, the signature of the shadow took place *one time only* [*une seule fois*], this occurred only once, and this time, like this woman, remains unique, singularly alone, absolutely solitary, absolute.

But that's not all. How is this (light) clarity *of* the night? Why does it appear not only to come out of and proceed from the night, as if black gave birth to white, but also to belong still to shadow, to remain still *at the heart* of the dark abyss from which it emanates?

There are two typical answers to this question. One appears classical: it recalls in its principle a truth of truth, the one that is imprinted and reflected in the entire history of philosophy since Plato. And this young woman will also exhibit, as much as a (philosophical) story and

history of modesty, of reserved nudity, an allegory of truth itself in its movement of veiling and unveiling: the origin of light, the visibility of the visible, that is, the black night, that which, letting things appear in the light [*la clarté*], by definition hides itself from view. That is what she does: she *hides from view* [*se dérobe à la vue*], she escapes from view by slowly exhibiting, making you wait in imminence, the gesture by which she suggests the movement of disrobing. Visibility itself is invisible, it is thus dark, obscure, nocturnal (*dark**) and it is necessary to be blind to it (immersed in darkness, *in the dark**) in order to see. In order to be able [*pouvoir*] to see [*voir*] and to know [*savoir*]. This law of the luminous phenomenon (*phōs*) is inscribed, from the origin, in nature (*physis*). Like a story of the eye. The laws of photography are in nature; they are physical laws; and to say this takes nothing away from the unheard-of event of this modern technique.

Against the abyssal background of this undeniable and ageless response, I can nonetheless see coming into view what might be called the *photographic* reply: a modern apparatus [*dispositif*], let's call it a technique, becomes the witness without witness, the prosthetic eye, an eye too many but invisible, at once producer and preserver, the origin and the archive of this insinuation of shadow at the heart of light, of everything that in *physis* thrusts clarity [*la clarté*] into the night, *light in the dark**, penetrating it without touching it, without the least noise, like an imperceptible thief with the force of a desire (this work shows, without saying anything about it, that which suspends photography upon desire and desire upon photography). The force of desire is an irresistible thief, but a thief who needs a witness and installs a camera even there where he defies the law. Thus *tekhnē* becomes the truth of *physis*; and the history of photography, as this work recalls — this singular work and this woman who cannot be dissociated from it, as might be done in other kinds of art — marks or gives to remark such an event; not the history of photography as the history of a technique or as the time of an ocular prosthesis which comes to surprise an already given light — in order *then* to inscribe it on an image and in order to make it *thereafter* into a reproducible archive. No, rather, the interposition of an optical apparatus coming to remind us that, in *physis* already, the *interstice* will have been open, like a shutter, so that photography might attest to it: so that the invisible witness like a third (*terstis*) might see and give to see, even there where seeing is

forbidden and hides in secret. Already in *physis* the difference between day and night could only appear in reversing their values. Nothing is more black than the visibility of light, nothing is clearer than this sunless night (lunar night, moonlight: go back to the first photograph, to the archi-still [*archi-photogramme*], the moon is there, a matrix-like [*matricielle*] moon): the photographic 'negative' to be developed, the always possible inversion of the projected image, the nudity of the body unveiled by the veil itself which calls for and suspends desire — these are so many indices or emblems. However extraordinary and irreducible the modern event might be, photographic mutation belongs, like all technique, to *physis*; it marks the différance of the relation to self in a *physis* that looks at itself, at herself, *one, unique, alone with herself*, she who comes and moves away from herself in the time it takes to see herself and thus blind herself to herself — and who loves herself. Who loves *to* hide, as Heraclitus said of *physis* (*kryptesthai philei*), and who thus, like this young woman whom I love (as a result) as much as she herself, which is to say more and more, loves to show that she hides on the very threshold of light. *All alone* [*Toute seule*], yet with herself, she figures (the) truth: *of* photography. Photography, these are the two points and everything that they suspend: incessantly, without waiting, like a negative in suspension, but by an instantaneous snapshot effect [*un effet d'instantané*].

Yes, for she is alone [*seule*]. Unique, irreplaceable, wholly other, over there, at a nearly infinite distance, on the other side of the Pacific, this young woman whom I could have met or loved, with whom I could have spoken, by telephone for example during a visit to Japan, is also, this wholly other, a living *allegory* (thus she could be anyone, any one, anywhere, there where the truth of *physis* could show itself and say itself in *something else, in someone else*, and everywhere there are photographic machines and some *tableau vivant* to bear witness to the without-witness, there where, as Celan says, *Niemand/zeugt für den/Zeugen*, No one/bears witness for/the witness).

From where does this emotion come? From where does it come to me? From her? This emotion is, I know, sustained by a non-knowledge, born, no doubt, of an indecision in which desire breathes. I don't know any longer, I don't know yet — will I ever succeed in knowing? — if I love this photographic work or this woman, on the verge of the name that I would like to give her but cannot, the name that I give her for

the first time as if I had given birth to her without ever having seen her and without any chance of ever seeing her, bringing her thus into the light of day, giving birth to her (*lui donnant le jour*, as we say in French), but giving birth to her in the night from which she comes and from which she distances herself at the same time, by blindly giving her a name that I nevertheless forbid myself, out of respect for her, to give to her? How is it that, sure of loving her, I no longer know if I love *this* work (*each* still [*photogramme*] and each still that stands alone — that is entirely alone like her, for she is absolutely alone looking at the camera that looks at her, to which she exposes herself so dangerously, offers herself so solemnly, refuses herself so gently, sometimes on the verge of tears that blur one's vision in order to show the eyes, and in silence she responds so attentively, waiting for an imminent event, like a birth that will never occur in slow motion, the prolonged duration of a purely phorographic narrative which is thus only the event of the day in its graphic revolution), if I love *this* work, thus, in the series, linked or interrupted, of a film, that is, of a thin film [*pellicule*] without history, I love *this* work, thus, irreplaceable, but also *this* young woman, entirely other and singular — and yet just any one (every other {one}, the wholly other, is every {bit} other [*tout autre est tout autre*])? No work of art, outside of photography, is so troubling. It is also the troubling confusion that, in reference, conflates the image and its model, the image this time and only once, once and for all [*une fois pour toutes*], only one for all, only one, inseparable from that of which it is an image. When I say and repeat that this young woman is alone [*seule*], I mean one time *alone* [une *seule* fois]. She signifies and gives to think the unthinkable: one *time* alone [une seule *fois*]. The photograph marks a date. What irreducibly belongs to the photographic effect, and Barthes had greatly insisted on this, is that the unique existence of the referent (here of *this* young woman whose name is a secret) is undeniably *posed* as the condition of the work (but I prefer to say *supposed*, and this changes almost everything), and that this young woman exists, that she posed, actually exposed herself once, twice, three times, and each time is a unique event, *one time alone* [une seule fois], even if, as in love, each caress prepares for another and advances in the imminence and metonymy of the other. Now this confusion between the actual existence of the 'referent' or of the 'subject' of the work, on the one hand, and the still, on the other, produces of itself what we could call

erotic confusion, the unsettling, troubling desire [*trouble de désir*] that goes toward the other, the other who is undeniable but only promised through its double, through the veil, the film, the membrane [*pellicule*] of the simulacrum, through modest emotion, the emotion *of* modesty and of the veil itself, thus of truth, disinterested emotion, emotion without measure, that is to say sublime, infinite renunciation at the heart of desire, this young woman, she and no other, inseparable from the photographic eye to which she was once exposed, more than once but each time one time alone [*une fois mais chaque fois une seule fois*].

Out of this confusion, we come to suspect that desire, even love itself, is always born of a certain photographic sketch. Everywhere love reveals itself to desire, that is through infinite renunciation, a photographic event will have already been called forth, we would even say, desired. Desire is also the desire of photography. From time immemorial. As long as there has been *physis*, and even if this goes way back, photography will always have been imminent, incessantly, imminence itself in desire. Imminence is of photography, of the photographic snapshot, the imminence of the shot as well, and we could play without playing at interpreting this entire series of poses: she awaits photography, the photography that makes others wait for it; all the signs of imminence that we read on the body of *Aletheia* (there we go, I named her, this time, the Greek name for truth all of the sudden resonates in my ear like a Japanese name), everything that we are tempted to decipher on her face, sometimes worried, questioning, timid, reserved, attentive, welcoming, this waiting without horizon, this waiting that does not know what is coming to surprise her, but which she prepares herself to want, this is the imminence of the photographic act. This act becomes, and there is nothing fortuitous about this, the metonymy of all possible *acts* (in the sense of the event and of the archive that records [*prend acte*] and preserves memory): the acts and certificates of love, birth, marriage, and death. More precisely, this metonymy in action [*en acte*] describes the imminence of these acts (love, marriage, birth or death) while it at once freezes movement in a snapshot and according to the shot [*cliché*] schematizes a *type* and thus makes possible the play of figures, photographic rhetoric. All these 'acts' are not separated or discrete. Each is also the figure of the other, what at the same time links, carries along, and nullifies all possible narrativity. This recounts the 'instantaneous' story and history

[*une histoire 'instantanée'*] of a series of 'snapshots' ['*instantanés*'] or paradoxical instants, of these impossible instants, as Kierkegaard would have said, whose decisive force interrupts but also makes possible the story and history.

At the center, for example (figure 29 [in the original Japanese edition — TR.], and the roll of film is made up of 54 of them), the figures of the virginal girl, the wife, and the dead woman are but one, the white light of the wedding flowers shrouds a child, while *Aletheia* can also be, with eyes closed, delivered over to the night of dreams. Through condensation and displacement, this reading could irradiate all the stills that precede or follow. And imminence, which describes the daybreak, the day breaking through [*poindre*] the night, the breaking through of the 'light of the dark'*, also signs all these instantaneous snapshots that are at the same time the movements and freeze frames of a film that turns around all the revolutions, beginning with that of day and night, of *light and dark**, of birth and death. Imminence is a movement of reserve, a movement without displacement, the suspension of a breath, the *epokhē* of what is going to happen but has not yet happened, the story that has not begun. Photography, when it is a great art, comes to surprise the instant of imminence, bearing witness to it and registering it [*prend acte*] in order to make it an irrecusable past. Testimony and evidence — and this would always be impossible — tend to become one and the same. How can the 'not yet' become and remain, like what it is, 'not yet', like what it is not yet, and when it is not yet, a past? It is *Aletheia*, the beloved photographed one, *Aletheia* ready to hide or veil her vision with tears.

She appears, and she appears alone. Absolutely alone, ab-solute, detached from everything. Solely visible. Visible but without witness, except for the eye that does not say 'I', the excluded third between her and me — that I foresee [*Que je devine*]. She remains alone with me, who is alone in looking at her alone exposed in a light or before an invisible eye — that I become [*Que je devienne*]. Because I would become thus. Not a single living person visible in the space around her; she is alone with the invisible visibility, alone with a desire for light, alone with the love of photography, which, instead of slipping away, instead of sweeping down upon her [*fondre sur elle*], comes to appear through her. *Poindre*. To come up, peep through, break through. I don't know any more if the too insistent use that I have made of this

word, as it imposes itself on me, and only on the basis of *Light of the Dark*, is in agreement with Barthes' use of it in *Camera Lucida*. I do not think so, but it matters little for the moment. I find it appropriate for the solitary singularity of *Aletheia*, for her solitude, so unbearable to us, for the held breath of all the imminences that I just mentioned but also for a breath that I feel right on her breasts and right on what in them points. The tip or pointing of the breasts dictates each of these words, it makes the mouth water with words and gives meaning to this space, to the space of this gaze that she invites for the caress, but also for the kiss — of the lover, of the newborn, of death.

Aletheia of photography: it, she, gives birth to light, promises it, nourishes it, poses it, expels it from herself like a newborn, exposes it and deposes it, brings it into the world and puts it to death.

To the questions 'How can she hide (me)? How can nudity veil? and how can modesty tear off its clothes?' — questions that interrogate no one other than *Aletheia* herself — we would be tempted to respond with a narrative that would feign to follow with some consequence, in their discrete sequence, each of these snapshots, one by one, one after the other.

Thus, at the moment when this could have taken a theatrical form in 50 acts, to tell the truth [*à la vérité*]

(for example: 1. *Raising of the curtain*. She waits — the dawning of the day — still she holds herself in the night, the day breaks through, she sees the event coming, she will always hold herself in imminence, she is inside and looks outside from where the day is coming, the ceremony has not yet begun. We see her on the edge, between the inside and the outside, in the opening of the window. Note that she holds herself in a corner. A slightly concerned curiosity: will what breaks through be something other than the day? 2. *Moonlight. Exposition, leaving the self*. She has left (but it is not the next moment, it is the same moment that overflows) the house, not far from the corner. The day dawns in the night, unless the sun is setting. Today will be the night's day. Alone with the moon, this time she turns toward the eye, ours, toward that of the optical instrument or the voyeur. She turns toward me while looking at another. She leaves me alone with the phantasm [*phantasme*] or the fantasy [*la fantaisie*], that is, of course, with a kind of light? No phantasm and thus no specter (*phantasma*) without photography — and vice versa. The distance will

never be surmounted between us; it is that of the day itself, of its veil and its film. Infinite renunciation: in the promise itself. Her dress from another time, the white collar (a boarding school for young girls, a school or convent, and there will always be, we are condemned to this, the visiting room between us). 3. *The threshold, the roof.* Always on the verge and at the corner, she turns toward the eye and exposes herself to the light; or rather, she prepares for the exhibition [*exposition*], as for ecstasy. The ex-position always comes to a standstill on the verge of ecstasy, like each of these stills. Apprehension, imminence, nothing has yet happened, nothing will ever happen, but she has already taken a step. We are in the past of this step [*pas*] toward that which is not yet and will never be — only the loneliness of photography, her loneliness, but which we can love up to ecstasy, on the verge of exhibition. 4. *The portrait.* To face up, to face [*Faire face*]. Fullface [*De face*]: in this very moment, in this book, 'here I am', she faces, before the law of the photographic phantasm, she exposes her face, in a dissymmetrical face-to-face with the eye without person, without anyone (without me), with the look from which her visibility appears. She looks at the eye that we do not see, mine for example, she stares at the invisible, and it is this that is '*dark*'*: myself (I {sink into} darkness [*je-sombre*]), this place of invisibility from which I look and which she looks at but that no one sees. Often, you see her looking outside, as we say, out the window, through a framed space, as on a screen. There shall be no witness for us. That is the absolute secret of this book, published to cry out 'here I am'. Everything will be possible on this day, this day of the night: birth, marriage, and death, promises made, promises broken. Everything remains possible, this album (the white of an album is always virginal) offers an immaculately matrix-like surface, like *khōra*, like *Right of Inspection*, for all the stories that you would like to project there, for all imaginable intrigues, 'plots'* and schemes.[9] She is only the actress in them, and the subject immediately withdraws. This mortal woman has just seen herself give birth, even seen herself see the day, she has just been born; she is a fiancée, a promised virgin, a mother who will also give birth and will see herself enshrouded in her wedding flowers. All of this will happen without happening. This will happen to the future, without happening to her, in the future [*Cela arrivera au futur, sans lui arriver, au futur*]. 5. *The home, the focal point [Le foyer] (domestic and optic) of seriality* — dwells [*demeure*]. At the moment that

the veil is lifted, and she begins to undress, the movement puts the image out of focus; and the laughter, but everything will have been already inscribed in an exhibit of photographs. A gallery, a bookstore, a photo archive, a passageway, a cemetery where one takes a walk on Sundays: a done deal. The book appears dedicated *to a female passerby*, to the memory of a passerby exposed to other passersby. *Aletheia* is no longer there for anyone. 6. *Come see, see (what is) coming* [*Voir venir*]. The exposed one exposes herself more, but not too much, she responds, she gives the impression of responding, she opens her mouth without saying anything: the point of the breast will always be promised to the impossible. To go much further...)

...in truth, then, it had to be given up [*à la vérité, donc, il a fallu renoncer*]. Imminence would not be able to last and one must be alone, as one must know.

— Translated by Pleshette DeArmitt and Kas Saghafi

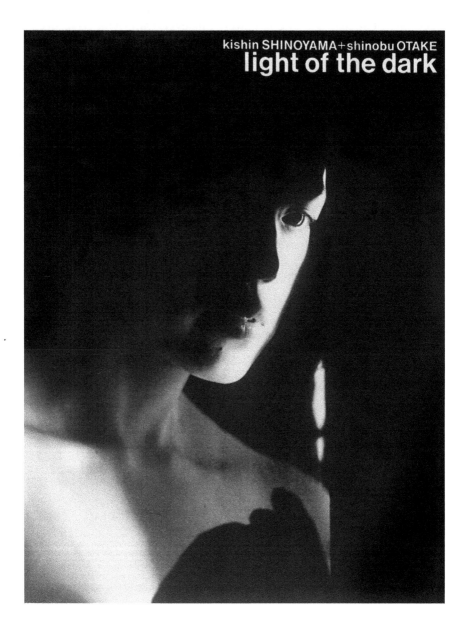

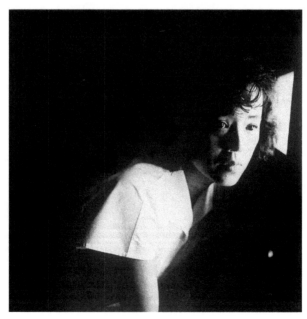

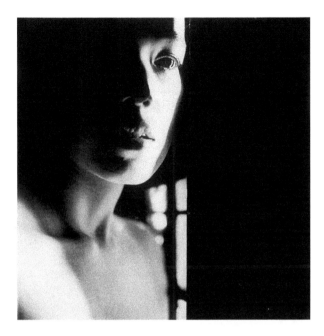

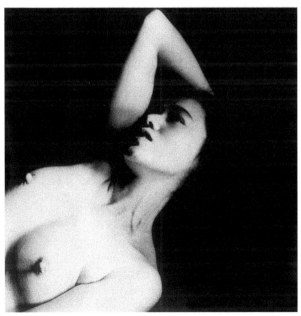

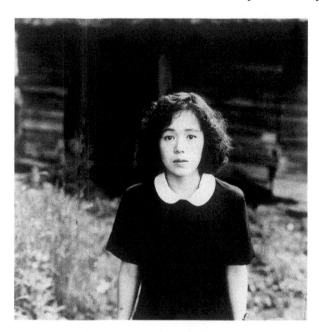

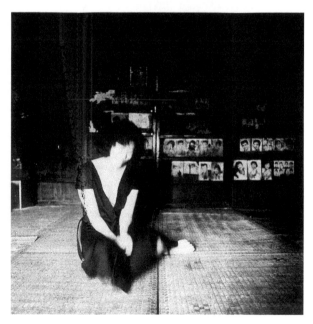

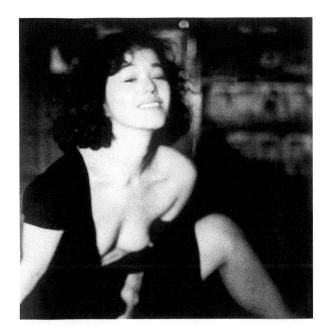

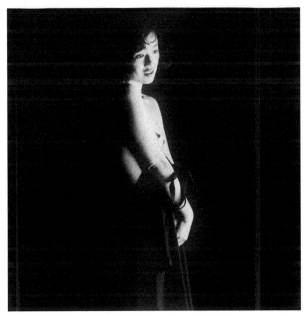

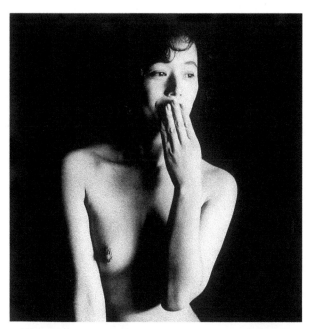

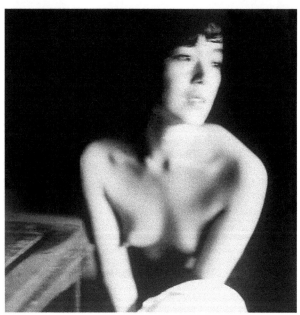

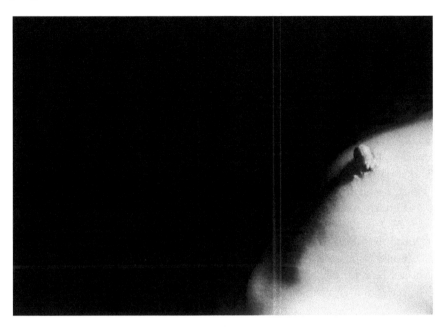

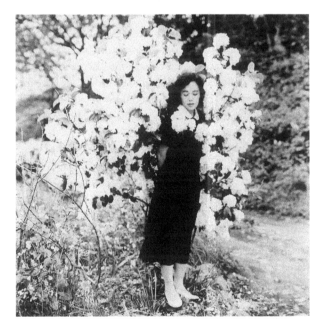

Notes

1 The original French edition of this essay bore the following note: 'Previously unpublished in French, this text first appeared in Japanese in the journal *Sincho* (March 1993). It was devoted to a volume of photographs published by Asahi Press in February 1993 in the series *Accidents 3*. The author of the book, Kishin Shinoyama, is as famous in Japan as his model, Shinobu Otake.

The original edition of the volume bore an English title, *Light of the Dark*. Published in oversize format (31/24), it had more than 50 photographs. While thanking Kishin Shinoyama, Shinobu Otake, the publishers of the book and the journal for giving us permission, we reproduce here, in a much more reduced format, the photographs that are explicitly named in Jacques Derrida's essay'.

This essay is a translation of the French version published in *'Nous avons voué notre vie à des signes'* (Bordeaux: William Blake & Co., 1996). The translators wish to thank Jean-Paul Michel for kindly granting us the rights for the translation. We would also like to express our deep gratitude to Pascale-Anne Brault and Michael Naas for carefully reading and commenting on drafts of this translation. The translation greatly benefited from their precise and elegant formulations. — TR.

2 In English in the original. All other English words and phrases in the original French edition will be marked with an*. — TR.

3 Jun'ichirō Tanizaki, *In Praise of Shadows*, trans. Thomas J. Harper and Edward G. Seidensticker (Stony Creek, CT: Leete's Island Books, 1977). In French *Eloge de l'ombre*, trans. René Sieffert (Paris: Publications orientalistes de France, 1977). While benefiting from the English translation of this work, we have tried to translate the references to the French translation of Tanizaki as literally as possible. For ease of comparison, we have provided in the footnotes the pagination of the French edition followed by that of the English translation. — TR.

4 p. 32/p. 9.

5 p. 52/p.18.

6 p. 69/p. 26.

7 Jun'ichiro Tanizaki's *Chijin no ai*, also known as *A Fool's Love*, is translated into English as *Naomi* (New York: Knopf, 1985). — TR.

8 p. 77/p. 30.

9 Marie-Françoise Plissart and Jacques Derrida, *Droit de regards* (Paris: Minuit, 1985); translated by David Wills as *Right of Inspection* (New York: The Monacelli Press, 1998).

What, in truth, is Photography? Notes after Kracauer

Andrew Benjamin

> In our response to photographs ... the desire for knowledge and the
> sense of beauty interpenetrate one another. Often photographs radiate
> beauty because they satisfy that desire. Moreover, in satisfying it by
> penetrating unknown celestial spaces and the recesses of matter, they
> afford glimpses of designs beautiful in their own right.[1]
>
> – Siegfried Kracauer

Keywords: Siegfried Kracauer, photography, truth, time, history.

1.

With photography there always seems to be a problem.[2] It is as though
photography is condemned to efface the truth.[3] Be it the truth of time
or the truth of memory — in the beginning of course it was the reality
of things — photography is deemed to stand in stark opposition to
another and more insistent sense of the real. While it will be necessary
to take up the question of that to which photography has been opposed,
it is best to proceed cautiously, since there is another question, or
at least what has to be allowed is the possibility of a different set of
concerns that join photography and truth. The question would be the
following: What is the truth of photography? Another more productive
way of posing the question would be to ask: What, in truth, is
photography? The repositioning of the question of photography stages
a move from a concern with the truth content of the photographic
image to one delimited by the existence of the photographic image.
Once the latter is central, what then matters are the qualities that work
to define photography itself. What this involves is a repositioning that

The Oxford Literary Review 32.2 (2010): 189–201
Edinburgh University Press
DOI: 10.3366/E0305149810000751
© The Oxford Literary Review
www.eupjournals.com/olr

moves the question of photography away from strictly epistemological concerns — i.e., what type of knowledge does the photographic image contain and thus present — to those determined by the possibility of establishing that which is proper to photography as photography. Propriety, as the term is being used in this context, pertains both to the history as well as to the nature of the photographic image. What this repositioning establishes as central is an ontologically determined conception of both the philosophy and the history of the image. What needs to be folded into these concerns is the recognition that the history of the production of the image changes within that history — e.g., the move from the analogue to the digital image — and thus cannot itself be separated straightforwardly from questions pertaining to the image. In other words, the photograph as a locus of meaning is the result of specific effects and techniques. Were the latter not to form part of any account both of the production of the image and the image's interpretation, then such an account would run the risk of idealizing content. It would be as though the image's production was irrelevant to its work as an image. The question that is intended to capture this array of concerns is the one posed above: What, in truth, is photography?

Rather than attempt to answer this question directly, a start will be made with the other possibility noted above, namely the identification of photography's having undone in advance a specific form of reality. As part of his meditation on the nature of the photographic image, Kracauer wrote: 'In order for history to present itself the mere surface coherence offered by photography must be destroyed' (*MO*, 52). Photography takes on the structure of historicism when what it presents is taken as axiomatically coherent. It would be as though there was a coincidence between the constructions of 'nature' and 'history' in which both are understood as forms of completion and totality. The destruction of 'coherence' is, for Kracauer, the creation of meaning. Moreover, there is a link between 'reason', destruction and the creation of meaning. Kracauer writes that 'reason speaks wherever it disintegrates the organic unity and rips open the natural surface' (*MO*, 84).

Despite the context in which such claims are made, what Kracauer is alluding to is the creation of a surface as nature — naturalizing the surface — then the destruction of that surface. Hence the denaturing

of nature: a denaturing occurring, of course, in the name of another possibility for nature.[4] Coherence is an aftereffect that takes on the quality of an immutable naturalized setting. With that created coherence meaning escapes. Thus he writes specifically of the photograph that 'the photographic archive assembles in effigy the last elements of a nature alienated from meaning' (*MO*, 62).

What is presented as a 'coherent' image has a number of interrelated qualities. Unlike any other art work, the photograph involves the creation of an image that has different modalities of existence. This range includes elements that even in their separation are still able to overlap. The photograph may be an art object, equally it may document, perhaps even function as evidence. The photograph may be integral to the life of a commodity. Indeed the commodity's existence within the photograph would have to form part of any account of the existence of the fetishism of the commodity. There is another aspect of the photograph — and it is an aspect that has always accompanied the history of the photograph — and that is its link to the personal if not the private. What all photographs bring with them is the relationship between memory and the personal. The suggestion would be that the photograph complicates the question of memory. This occurs by the image's continual recall of a distinction, a distinction whose quality is, of course, yet to be addressed, between the link that photography has to the way historical time is to be understood, this is, of course, the force of Kracauer's point noted above concerning 'coherence', and personal memory. The latter is identified, though only initially, with the presentation of an enclosed personal world. That world, which takes the uniquely personal as its point of orientation, holds open the possibility of staging a form of personal involvement with that which would leave an other viewer uninvolved. Being involved is a way, *albeit* an initial and still tentative way, of identifying the problematic relationship between history and memory, on the one hand, and the personal, on the other. (It needs to be added that neither involvement nor being uninvolved have a form of necessity attached to them. They are a contingent aspect of the viewer/image relation that depends upon the particularity of the viewer. Indeed it is the structure that yields the viewer as a particular; thus, though this stands in need of greater clarification, the personal would be the moment of non-universalisable particularity.)

As an opening, the presence of the personal as a locus of presentation has to be understood as having been integral to the origin of photography. A private world acquired an image within the personal portrait. A photographic motif—the presentation of a private world—that had its most emphatic form of presence in the photographic *memento mori*. Such photographs draw on a tradition within painting in which they functioned as reminders of death. And yet, with the photographic *memento mori* there was a radical differentiation from that tradition. Painting involved a sense of abstraction that pertained *ab intitio*. The photographic *memento mori* had a far more complex relation to abstraction. While functioning as reminders of death, these works inscribed images of death into life. The newly dead were dressed and posed in life-like positions. There were both family shots and forms of portraiture in which the appearance of life was given to the dead and thus the dead were allowed a version of life. It was as though in such photographs reminders of finitude took on a different quality. At the same time, these photographs were deeply personal. It is not just that they were of someone's relative or friend. Of greater significance is the fact that they were posed and then the subsequent photograph taken in order that the result display and then be displayed in a domestic setting. While always able to function as a cultural artifact that indicated important changes in attitudes both to death and the representation of the image of death, it is also the case that they were, at the same time, objects whose personal status was marked by intensity and exclusivity. Initially they were both.

While the *memento mori* is an extreme form, its presence underscores the capacity of the photograph to oscillate between the personal and any other form of presence that can be attributed to it (e.g., photograph as cultural artifact). And yet, it is precisely the nature of its personal presence — its having been a photograph that involved actual presence and that allowed the image to function significantly within a set of personal relations, a set of relations in which on viewing the photograph the viewer would have been involved — that is integral to the photographic image. Now, on viewing such photographs the viewer is held at a distance. While there could be a type of connection that can be made to the presentation of personal relations within the image, there will be the registration of the portrayed dead. It remains the case that the response to such images will be structured by a form

of empathy predicated upon abstraction. No response could be situated within a structure of actual knowledge. The dead are unknown. There are simply images of the dead. Thus, while it may be possible to move from the presentation of the specifically personal to that presentation having an effect through a process of abstraction, nonetheless the contextualizing element can only ever be noted. The viewer could only ever be involved as an aftereffect, namely, the effect of the interplay of abstraction and projection (the former being the precondition for the latter). Nonetheless, what endures with the photograph is its having had a specific determined context. The *memento mori* is not just the personalization of the presentation of life; it is, after all, the intentional personalization of presentation insofar as the presented image is of a deceased relative or friend. Nonetheless, it positions the viewer through its presentation, not of finitude as an empty abstraction, but of finitude as personified, as it were, in the corpse as living on within death, and yet of course not living on because dead, of an identifiable and once named human being. After the possibility of actual knowledge, however, what continues is a relationship between reality and abstraction. That relationship is an integral quality of the image.

It is in connection to the question of involvement or positioning — of having been positioned, of allowing oneself to be involved, of having been exposed to the image — that two further elements that are equally fundamental qualities of the photograph need to be introduced. The first involves clarifying the relationship between the impersonal and the personal. Within that process it will become possible to reposition the apparently personal in terms of a quality of the image that is inherently indeterminate. The second concerns tracing the consequences of the operative presence of that distinction — the impersonal and the personal — on what Kracauer identifies as 'coherence' and the consequent need for its destruction. Coherence and destruction concern the relationship between the photographic image and questions pertaining to historical time.

2.

In the course of a remarkable text on both the intellectual as well the physical (bodily) presence of viewing cinema, Roland Barthes writes of his experience in the cinema in terms of having two bodies in one. The first is attentive to the image, while the body — in the second

sense — is held by that which 'exceeds' the image. Their temporal simultaneity is fundamental. What exceeds the image is as much the physicality of the setting (light, odour, etc.,) as the sound that accompanies the presentation of images on the screen. Here there is a distancing from the image, which, at the same time, accompanies the image in its being viewed. It is possible to go on and add, even though this is not strictly Barthes's own argument, that this 'fascination', that which exceeds the image, is itself dependent upon the image. Of this distance Barthes writes that it is not established by 'critique (intellectual); it is, if one can say it, a loving distance'.[5] Nonetheless, what matters is the distance and the maintenance of the image within the continuity of distancing. (The film matters within this distance.) The inscription of an ineliminable sense of distancing reinforces the argument that Barthes makes elsewhere in relation to his analysis of the stills from a film by Eisenstein.[6] After noting both the denotative as well as the connotative quality of the image, and here the stills, within Barthes's analysis, function as photographs, Barthes begins, in response to his own question — 'is that all there is?' — to identify what he refers to in that context as a 'third meaning' [*troisième sens*]. While neither connotative nor denotative in orientation, the 'third meaning' is, nonetheless, a quality of the image. Its presence can be located. Moreover, in his work on photography, *La chambre claire*, the distinction between the 'studium' and the 'punctum' allows for the distinction between the impersonal and the personal qualities of a photograph to be presented in similar terms.[7]

While the cases differ, what is important in both instances is the identification of a quality — though equally an identifiable and nameable element of the photographic image — which, because it cannot be equated with either the denotative or the connotative, opens up a different space of relationality. There is, however, an important question that occurs once this space is opened up: who is the subject within that relation? What is of central importance here is that there cannot be a generalized answer. In part this is because there is a fundamental ambiguity at work within the conception of image that sustains Barthes's general argument. On the one hand, it is essential to argue that there is a quality of a work that cannot be reduced to any one specific determination (Barthes understands determination in this context in terms of connotation and denotation). He wants to hold to

the position that any image is accompanied by that which sustains and exceeds it. The ambiguity emerges at this precise point. The quality that allows for the excessive, the quality that is operative but exceeds the codes of meaning, is a quality of the work, in the precise sense that the 'third meaning' and the 'punctum' are identifiable elements of a given work. And yet, they are also dependent upon the relation between a given viewer and the work.[8] They have therefore a necessity, in that they are qualities of the image, and a contingency insofar as they are subject dependent (where the subject is always specific rather than generalizable). In other words, there is a relativity in regards to the viewer even though this accompanies the presence of a quality of the work that cannot be reduced to already given determinations.

What Barthes has identified is a fundamental quality of the image. The difficulty is that this quality is then conflated with a relation to the image that depends upon the history of a given subject. As the discussion of the *memento mori* above indicated, there is no doubt that a photograph can present a scene that is imbued with a certain reality and that because the passage of time has the effect of providing the reality's insistence with an abstract quality, it then becomes possible for the image to function as a locus of personal relations, identifications and projections. (Fundamental to this position is the capacity of the real to maintain a given 'reality' while at the some time becoming abstract.) The argument would be, therefore, that what allows for the image to resist modes of determination that intended to give it an interpretive finality is a quality of the object. In general terms it would be the inherent impossibility of a one-to-one relation of an object of interpretation with a specific interpretation — this is, of course, a claim not about semantic relativism but about the nature of an object of interpretation. Specifically, however, it is a claim about the photographic image. It is the latter that is fundamental here. While what is important is that both the 'punctum' and the identification of the 'third meaning' look as though they are personal and subjective and thus their relation to the object are purely subjective, this is not the case. Both are allowed for by the image in the precise sense that both form part of the image. The nature of the photograph, part of what the photograph is in truth, includes its capacity to move between the real and the abstract in the precise sense that the photographic image allows what would be taken to be 'real' to be determined in advance

by a sense of abstraction in which the real can no longer be reduced to the reality that it is taken to present. The image will always have been in excess of that reality. Excess here is an irreducibility to content. In part this occurs because reality will have become unknown — at its most elementary this is the consequence of the passage of chronological time — and in part it is due to the real's capacity to be both itself and abstract. The latter is an insistent and ineliminable part of the photographic image. The real is not doubled as though all it had was a twofold quality. The reality of the photographic image is marked by a founding plurality. There is irreducibility, thus founding plurality, which initially seemed to be the relation between the personal and the impersonal though what was actually at stake was a relationship between the determined and indeterminate (a relation in which these aspects of the image continue as inherently imbricated). The latter, the indeterminate, which appears in Barthes's writings in terms of the 'third meaning' and the 'punctum', are not personal projections but a part of the image itself. This irreducibility and thus the impossibility of a *reductio ad unam* — which, once again, is a quality of the image, and thus that which is proper to the photographic image — repositions the image as a plural event.[9]

3.

The second aspect of the photographic image that has to be taken up — the aspect already there in Kracauer's identification of a link between the photo and 'historicism' — concerns the relationship between the image and time. There needs to be a number of preliminary moves made prior to addressing the substantive question of the relationship between the image and historical time. There are several senses in which time pertains to the image. Hence, while there are a number of different ways of addressing the relationship between time and the image, here that relationship will be addressed in terms of photography's necessary incorporation of what will be described as the problematic of *the next moment*. This moment provides the link between the interplay of the personal and impersonal, on the one hand, and the complex presence of issues arising from a concern with historical time, on the other. The problematic of *the next moment* occurs because formally photography is determined by staged excisions and exclusions in the first instance and staged inclusions in the second. The content is determined equally

by what is excluded and what is included. Exclusion and excision are as much spatial as they are temporal. Hence what every photograph already notes is the presence of an absence. The question that has to be addressed is how that absence is to be understood. Noting absence is, on its own, far from sufficient if what is essential is an account of the image's work and thus an account that would form part of a sustained response to the opening question: What, in truth, is photography?

In the first instance the problematic of *the next moment* emerges due to photography's relation to a sense of the real. Even if the real has been constructed, it still exists within the frame. Even though it harbours a relation to abstraction — a relation that is itself only possible because of exclusion and inclusion — the real is a moment. A leaf moves, a smile occurs, hands touch, and strangers pass each other on the street. In the next moment, the leaf is at rest, the smile has become a laugh, hands part, and a different set of strangers pass each other. In all of these instances activity is equated with a moment. The photographic image presents that moment. What it cannot present is of course *the next moment*. In not presenting it, it excises that moment. The image in virtue of its presence as a photograph has been separated from a continuum. That separation is the creation of the photographic image. At that precise point the possibility of *the next moment* is suspended. Hence what would it mean to argue that precisely because there could have been another moment — more emphatically there would always have been another moment — then the recognition of a future delimited by the next endures as a potentiality within the image? The presence of such an argument is important. It brings with it two senses of continuity. In the first instance it means that to argue that the problematic of *the next moment* is retained as a potentiality means the past — the past as the past moment — has been excised by the image's creation, an excision that is in some sense retained. Retention is the presence of reiteration as continuity. At the same time, however, the possibility that the image could open onto a future has been forestalled. What is important here is the conception of the future that such a mode of argumentation intends. As is clear, the intended future, indeed the only future that would have been possible, is the future as *the next moment*. Here it should be remembered that the future is the future held within the sense of continuity provided by the content of the image. What was next is, of course, only there as what could have been.

Arguing for the retained presence of what could have been is to inscribe the image within a form of temporal continuity. Continuity locates the image within time, which is identified with the sequential nature of chronological time.

The second sense of continuity is related to the first. In this instance, rather than the presence of a continuity in which the image is located, the supposition is that the contents of any one image are themselves continuous. As such, when taken together they comprise the moment that occurs when the relation to the next moment is suspended. That suspension occurs within and as a result of the retention of a conception of time as sequence. Within it the photographic image is the consequence of the sequence's suspension. Where, moreover, the image is taken as having included within it, as an absent presence, those moments that would have been present. Even allowing for the presence of an absent set of possible relations, precisely because they are defined in terms of possibilities — possibilities whose actualization would have suspended the suspension of *the next moment* and reestablished sequence and continuity — the internal contents of the image are themselves taken to be both temporally as well as spatially coherent.

What characterizes the two senses of continuity that mark the presence of the problematic of *the next moment* is the following. While there is in fact a form of suspension that is the creation of the photographic image, by insisting on a temporal continuity in which the image is incorporated only as a moment in time, where time is simply a sequence of moments, the image is reduced to a moment in time and as a consequence the particularity of the image *qua* image is not addressed. (This is the position alluded to earlier in terms of the propriety of the image.) This will be equally the case in relation to the projected internal coherence and continuity of the image. Once it can be argued that the image contains elements that are themselves continuous and thus only discontinuous with both the preceding moment and *the next moment* because of a suspension of those temporal relations, then once again what is not offered is an account of the image that assumes a distinction between the presence of the image *qua* image and any claims made about the broader setting that can incorporate the image. Acts of interpretation that identify the particularity of the photographic image as the result of the problematic of *the next moment* would involve the sustained refusal to engage with the specificity of the image.

Potentiality within the image does not involve a relation to the future. Potentiality is present as a quality of the image due to the irreducibility of the abstract and the real, on the one hand, as well as the incorporation within any understanding of their work of the techniques of which they are the result, on the other. To get to this position what has to be suspended is the problematic of *the next moment*. As has already been indicated, it is the moment of external and internal coherence. *The next moment* — or the structure of *the next moment* — must be suspended if the relationship between the photographic image and time is to be rethought. The suspension of *the next moment* would become therefore the critical interruption.

When the photograph is allowed to become the site of work, this is the point at which the problematic of *the next moment* is itself suspended. As a result, what then becomes central is the emergence of the image as a locus of techniques rather than a place of assumed if yet to be determined meanings. As a consequence, rather than identifying particularity with a personalized state — the viewer as a particular — particularity pertains to the work or, here, to the photographic image (the image *qua* image). In other words, an insistence on both particularity and techniques allows for the breaking of the determination of the image by the problematic of *the next moment*. This suspension — an interruption that allows — opens up another possibility for photography. This is a position alluded to by Kracauer in what he refers to as the activities of a 'liberated consciousness'. For Kracauer the coherence of the elements of a photograph is in fact 'provisional'. What this means is that they could never count as discrete moments. Hence he writes:

> It is therefore incumbent on consciousness to establish the provisional status of all such configurations, and perhaps even to awaken an inkling of the right order of the inventory of nature. In the works of Franz Kafka, a liberated consciousness absolves itself of this responsibility by destroying all natural reality and scrambling the fragments. The disorder of the detritus reflected in photography cannot be elucidated more clearly than through the suspension of every habitual relationship among the elements of nature. (*MO*, 62)

Suspension and destruction become the undoing of the hold of the real as a given and the temporality of sequential continuity as that within which it is articulated. Their interrelation positions photography to present moments that occur within it. Undoing this 'reality' is a twofold process. In the first instance it involves a critical interpretive practice — criticism — in which the object of criticism is the relationship between particularity and techniques. (That relationship is, after all, what photography is, in truth.) Equally, it opens up as a practice that which would take as its productive prompt the project of undoing both the place and the determining hold of the habitual. The reconfiguration of nature, a move that has to reconfigure historical time, opens up the space of different habits. Habits are practices, once the equation of habit and repetition is suspended. With that suspension, the practice of photography can continue to occur again differently.

Notes

[1] Sigfried Kracauer, *Theory of Film* (Princeton University Press, 1997), 22.

[2] I want to think Deane Williams for inviting me to speak at the conference *Provisional Insight: Siegfried Kracauer in the 21st Century*, which was held on 18–19 July 2008 at Monash University. These notes, while not on Kracauer directly, make use of his 1928 paper *Die Photgraphie* as the setting in which to address questions posed to philosophy by the photographic image. Kracauer's text is translated and published in *The Mass Ornament*, trans. Thomas Y. Levin (Cambridge: Harvard University Press, 1995). References to the essay on photography and to other essays in the volume are given as *MO* plus page number.

[3] While it cannot be pursued here, early accounts of photography, in Baudelaire, Zola and Proust, amongst others, were committed to the proposition that beauty, the real and the complex relationship between time and memory, could not be presented in photographic form. Absent from all of their concerns was, of course, the possibility that the photograph was itself a specific form of image creation that demanded to be defined in terms that were appropriate to it.

[4] A similar project in relation to 'nature' can be traced in the writings of Walter Benjamin. See in this regard my 'Messianic Nature: Notes on Walter Benjamin's *Theological-Political Fragment*', in *Limbus: australisches Jahrbuch für germanistische Literatur und Kulturwissenschaft. Australian yearbook of German literary and cultural studies*, 2010.

5 Roland Barthes, 'En sortant du cinema', in *Oeuvres Complètes* IV (Paris: Editions du Seuil, 2002), 782.

6 Roland Barthes, 'Le troisième sens (Sur Eisenstein)', in *Oeuvres Complètes* III (Paris: Editions du Seuil, 2002), 485–506.

7 *La chambre claire* in Roland Barthes. *Oeuvres Complètes* V (Paris: Editions du Seuil, 2002), 791–887.

8 Barthes expresses this state of affairs in *La chambre claire* when he suggests that punctum is 'what I add to the photo and which however is already there'. *Oeuvres Complètes* V, 833.

9 For the development of this term in a broader philosophical context, see my *The Plural Event* (London: Routledge, 1993).

Primal Phenomena and Photography

Elaine P. Miller

> The person who created this collection of plant photos ... has done more than his share of that great stock-taking of the inventory of human perception that will alter our image of the world in as yet unforeseen ways.
>
> — Walter Benjamin, 'News About Flowers'

Keywords: Primal Phenomenon, Optical Unconscious, Photograph, Kristeva, Benjamin, Adorno, Aesthetics.

This paper considers the idea of the photograph as an artform that is capable of manifesting what Johann Wolfgang von Goethe called an *Urphänomen*, or primal phenomenon, a sensuous ideal form (in Goethe's case, of nature) that allows the being of the whole context to which it belongs to be understood. By looking at the writing of Walter Benjamin, Theodor Adorno and Julia Kristeva, I will interpret the primal phenomenon, which Benjamin discusses as a phenomenon in history and in art, in terms of what he calls the optical unconscious made manifest through photography. Since Benjamin writes that the optical unconscious that photography exposes is the counterpart of the psychic unconscious, I will try to understand the primal phenomenon from a contemporary perspective with the aid of psychoanalytic theory, in particular that which informs Kristeva's aesthetics.

It is notable how many photographers have been inspired by the notion of the primal phenomenon, in particular by the primal plant that Goethe describes in *The Metamorphosis of Plants*. Taking my cue from Benjamin's essays on photography and on Goethe, I will

The Oxford Literary Review 32.2 (2010): 203–230
Edinburgh University Press
DOI: 10.3366/E0305149810000763
© The Oxford Literary Review
www.eupjournals.com/olr

develop the notion of the photograph/artwork as having the capacity to manifest primal phenomena. Following Benjamin's articulation of the flashlike temporality of the photograph in conjunction with Kristeva's notion of the semiotic traces that punctuate symbolic expression, I speculate that what some artworks achieve is a momentary incision into the patterns of everyday imaginary life, opening up a vision of what I am referring to as a primal phenomenon. Like flashes from the unconscious, which periodically and unpredictably punctuate conscious life, these moments are neither intentional nor controllable, though they inform and can possibly transform the structure of significance from which they emerge. This idea of the photograph as punctuation by primal phenomena will be elucidated here with reference to psychoanalytic theory, in particular the aesthetic theory of Kristeva. I will also consider the juxtaposition of photography and primal phenomena with reference to Kafka's writings, which Adorno compared to photographs of the earth taken from space, and conclude by considering some examples of contemporary photography in light of this conjunction of theories.

Benjamin: A Little History of Photography

Walter Benjamin's brief but suggestive meditations on the (then) relatively new art of photography indicate that Benjamin considered the photograph's capacity to capture and freeze an image to be a manifestation of the distinctive temporality of modernity.[1] The photograph, unlike any art form of the past, was subject to the possibility of an infinite progression of identical and substitutable reproductions, which seemed to relegate it to the status of an item for consumption rather than for reflection. While recognising this tendency, Benjamin also discerned in photography a new and potentially redemptive capacity that could provide a response to the very critique of modernity it evoked. This possibility had to do both with the photograph's power to capture the 'unconscious' of a given moment, beyond the explicit intentions of the photographer, and with its capacity to preserve a moment of lost time in such a way that it would not merely retrieve or repeat it identically, cutting it off from its context in the flow of experience, but rather open up the possibility of an alternate way to retrace enigmatic and elusive memory paths so as to reawaken the lost past.

In 'Little History of Photography', Benjamin considers the photograph with reference to the concept of the aura that he eventually developed further in 'The Work of Art in the Age of its Mechanical Reproducibility'.[2] Although the earliest photographic portraits seem to manifest a kind of aura due to the darkness that surrounds their subjects, who emerge from them full and serene, framed by a 'breathy halo' that is the product of technology, their aura is nonetheless very different from that of painterly portraits that preceded them.

Aura, as Benjamin uses it in discussing photography, is a 'strange weave of space and time; the unique appearance or semblance of distance, no matter how close it may be' ('LHP', 518). One could speak of the aura of a city, such as Paris, or the aura of a person that pervades her clothing and surroundings without being reducible to any of their particularities. For example, Benjamin describes a certain photographer's subject as 'a member of a rising class equipped with an aura that had seeped into the very folds of the man's frock coat or floppy cravat' ('LHP', 517). Interestingly, Benjamin argues that it was precisely with the development of the ability to decisively simulate the original, 'natural' aura of the person or place (early photography was exceedingly artificial) that photography began to decline ('LHP', 517). This is because as advances in optics began to allow for the exact recording of natural appearances as in a mirror, photography tended more and more to adhere to the traditional conception of art as imitation of nature. As a result, theoreticians of photography began to 'attempt to legitimate the photographer before the very tribunal he was in the process of overturning' ('LHP', 508).

The reproducibility of the industrialised photograph, then, negates its simulated aura, for, as Benjamin writes in 'The Work of Art in the Age of its Mechanical Reproducibility', aura traditionally signifies the singularity of the original, its history and its authority. Film and commercial photography substitute for the original a plurality of copies, allowing a multiplicity of viewers to encounter the image, each in his or her own particular situation: 'it substitutes a mass existence for a unique existence.'[3]

In the essay on photography Benjamin is concerned with distilling the real artistic essence of photography, what makes it distinct as an artform. He argues that when photography tries to imitate nature or traditional forms of representational art, it is not true to its essential

nature. The two aspects of photography that Benjamin finds most distinctive and significant are its incorporation of the unconscious and its temporality. Both of these aspects are in some way erased or at least minimised in industrialised or technically advanced photography. Nonetheless, both also come to the fore strikingly in certain forms of post-industrial photography.

Benjamin first indicates the presence within photography of a 'space informed by the unconscious', as well as the flashlike complexity of the photograph's temporality, in his discussion of the earliest of photographic plates. Unlike painting or other traditional artforms, photography evokes an irresistible urge on the part of the beholder to discern within it a 'tiny spark of contingency, of the here and now' that the photograph through a lengthy exposure has 'seared' into the subject ('LHP', 510). What distinguishes the photograph is that it records an actual moment of lost time. This spark is described by Benjamin as 'an inconspicuous spot where in the immediacy of that long-forgotten moment the future nests so eloquently that we, looking back, may rediscover it' ('LHP', 510). This is also the temporality of Proust's involuntary memory and of Freud's *Nachträglichkeit*.[4] In *In Search of Lost Time* the narrator Marcel feels the past, the present and the future of the past touch as he tastes a bit of madeleine soaked in linden tea. And Freud himself makes the connexion between *Nachträglichkeit* and the photograph when he compares the unconscious to the photographic negative, which may be developed immediately, long after the moment it was imprinted, or not at all.[5]

Benjamin goes on to claim, however, that no matter how carefully the photographer has attempted to faithfully capture nature as in a mirror, 'it is another nature which speaks to the camera rather than to the eye: "other" above all in the sense that a space informed by human consciousness gives way to a space informed by the unconscious' ('LHP', 510). This 'optical unconscious' is revealed by the techniques to which photography has access, techniques of freezing and then enlarging a particular view, and, in the case of film, of slowing motion down so that we may become aware of its component parts, that fraction of a second when a person takes a step or shifts a limb. 'It is through photography', Benjamin writes, 'that we first discover the existence of the optical unconscious, just as we discover the instinctual unconscious through psychoanalysis' ('LHP', 511–12; see also 'WA'

266). Photography can reveal things that are not available to the ordinary eye.[6] It is precisely in appearances being frozen and thus cut off from their context (for context is an integral part of the aura) that the optical unconscious can be accessed. Photography thus also functions in a manner analogous to Freud's concept of negation, as an indirect route to repressed content.[7]

As an example, Benjamin points to an early photograph of the photographer Karl Dauthendey, who posed himself beside his fiancée, a woman who would commit suicide shortly after the birth of their sixth child. Though Dauthendey seems to be firmly holding on to his fiancée, anchoring her to the present, 'her gaze passes him by, absorbed in an ominous distance' ('LHP', 510). Here we see a moment frozen in time that, from the perspective of knowledge in the present, seems to have nested within it an indication of something unconscious that suggests future events.

Roland Barthes identifies death as the *punctum* of every photograph — not the *studium*, or subject of the photograph, but the point in the photograph that 'pierces' us and draws us out of it, a point that is therefore active rather than passive. A photograph with a *studium* and no *punctum* would be a mere representational likeness. In the case of a photographic portrait, what is captured is an actual moment of life, a moment in the flow of self-consciousness, immobilised and presented for observation. By contrast, in the case of a painted portrait, what is presented is the product of the imagination of the artist. Photography must thus be understood as the cutting off of a moment of time as opposed to a seamless narrative or a woven fantasy. It has a 'flashlike' or 'explosive' temporality that is akin to the 'flash' of mimesis that Benjamin discerns in some forms of language.[8]

In interpreting a photograph, the point is not to redeem the image by inserting it into a narrative that would identify and contextualise it, but to recognise the 'now time' of interpretation in its relationship to the past. That is because a photograph, in the words of Barthes, sets up 'not a perception of the *being-there* of an object ... but a perception of its *having-been-there*. It is a question of a new category of space-time: spatial immediacy and temporal anteriority'.[9] Successful photography does not duplicate a moment but 'mimes' it, where what results is ambiguous, suggesting a 'magical correspondence' between past and

present akin to the correspondences familiar to ancient people, for example, a similarity between a constellation of stars and a human.

Adorno: Photographic Negativity

Benjamin's discussions of photography presage, in my view, a development in avant-garde art that his interlocutor, Theodor Adorno, either rejected out of hand or was unable to foresee. In Adorno's dispute with Benjamin over the revolutionary potential of the mechanical reproducibility of some forms of art there seems to be an assumption that an artform that is embraced by popular culture (think of Adorno's dismissal of jazz) is categorically incapable of having any real political impact because it is already so embroiled in precisely what political analysis attempts to critique.[10] Photography and film, like jazz, according to this argument, would be too implicated in the logic of instrumental rationality and consumer culture to be able to maintain a critical distance on it or to envision an alternative to it.[11]

Interestingly, however, Adorno used a metaphor of the photographic negative to illustrate a revolutionary political perspective that only art is capable of achieving. He describes Samuel Beckett's literature as producing a 'second world' of images that manifests the poverty and hollowing out of the subject and of reality under late capitalism, not by replicating that experience, but by miming its social spell in the form of a 'photographic negative of the administered world'.[12] For Adorno, negation, or, as Shierry Weber Nicholson puts it, 'the capacity to see things in an unearthly light' or to 'present a version of the world in negative', would be the primary way in which art can have political significance, both in terms of exposing the loss of experience under the spell of instrumental rationality and by suggesting that things could be otherwise. Adorno also illustrates this view photographically in a letter to Benjamin in which he refers to his own early interpretation of Kafka as representing 'a photograph of our earthly life from the perspective of a redeemed life',[13] a notion that we will examine in more detail in the next section. It is arguable, however, whether Adorno thought actual photographs could have this effect.

Adorno castigated the vulgar materialist notion that thought or the subject must 'mulishly mirror the object', calling this 'image theory'.[14] Here we can see a parallel to Benjamin's critique of industrialised photography, in which the photograph is conceptualised

as an exact reproduction or 'mulish mirror' of an object, one that can be reproduced infinitely.[15] Benjamin's theory of the true nature of photography indicates that successful photographs always contain a surplus beyond what they merely represent, although the tendency to equate photographs with what they represent can detract from that surplus. This surplus that cannot be contained within the image would refer to the unconscious as much as to what might be indefinitely indicated as the divine.

The conjunction of nonsensuous similarity (mimesis), flashlike temporality and the opening up of a space of the unconscious can be found in some examples of contemporary photography. In Benjamin's own discussion of the photographer Eugène Atget, we get a sense of the possibilities he views in photography in its post-representational phase. He calls Atget's Paris photos 'the forerunners of Surrealist photography' in their successful cleansing of the stifling atmosphere of conventional portrait photography ('LHP', 518). These photos, which show only details, bits of trees or architectural fragments, lampposts or balustrades cast adrift from their context, initiate 'the emancipation of object from aura' ('LHP', 518). This emancipation is necessary in the industrial age, where 'even the singular, the unique, is divested of its uniqueness — by means of its reproduction' ('LHP', 519). Benjamin calls this a 'salutary estrangement between man and his surroundings', giving 'free play to the politically educated eye' ('LHP', 519). Atget's photographs are likened to crime scenes ('LHP', 527; see also 'WA' 258). But, Benjamin asks:

> Isn't every square inch of our cities a crime scene? Every passer-by a culprit? Isn't it the task of the photographer — descendant of the augurs and haruspices — to reveal guilt and to point out the guilty in his photographs? ('LHP', 527)

Benjamin thus interprets the photographic art as discomfiting, as alienating, and as such as possessing the power to force one out of one's accustomed habits of observation. At the same time, just as a crime scene indicates a cryptic scene of undoing that asks to be decoded and set aright, photography suggests that one or one's society could ultimately be different, perhaps even pointing out who is responsible for the misdeed. In freezing the moment, photography has the capacity

to provide both evidence of wrongdoing and the hope for justice or restitution. And it indicates the link between photography in its true nature and death, as well as, possibly, redemption. A photograph can make a lost moment present. Thus Benjamin ties the flashlike temporality of the photograph to the instant of messianic time, or the possible time of redemption, which may erupt at any moment through the linear time of history.

Primal Phenomena
As previously mentioned, Benjamin and Adorno did not concur over the aesthetic value of photography. While Benjamin was fascinated with the way in which the camera can capture that which is normally invisible to the observing eye (that is, the 'optical unconscious') and with the peculiar temporality of photography, its capacity to freeze a moment and make present a temporal anteriority that illuminates the present, Adorno saw in photography and in particular in film a tendency or perhaps a temptation more marked than any other artform to reproduce reality in a straightforward sense of mimesis as representation. Nevertheless, Adorno's conception of photography as a metaphor for the political function of literary art can be read as a counterpart to Benjamin's discussion of the photograph. Although Adorno criticised Benjamin's claim that there were redemptive and revolutionary possibilities in photography and in film as works of art, he nonetheless did concur that there was something compelling about the conceptual framework according to which Benjamin described photography. In particular, the two thinkers' views converge in an interesting manner in relation to their commentary on and discussion of Kafka, with respect to which Adorno writes to Benjamin that 'our agreement in philosophical fundamentals has never impressed itself upon my mind more perfectly than it does here' (*CC*, 66).

Benjamin's essay on Kafka is informed by his conception of *Urgeschichte* or primal history, whose temporality, like that of the photograph, is in the future anterior. Illuminating unrecognised moments of the past in a movement that Benjamin describes as 'flashlike', the articulation of primal history both preserves the past from oblivion and illuminates the possible future as the unredeemed or repressed consequence of those forgotten moments. To understand primal history, one must glean a conception from multiple fragmentary

sources. In *The Arcades Project* Benjamin describes primal history and the conception of origin he traced in *The Origin of German Tragic Drama* as analogous to Goethe's conception of the *Ur*-phenomenon, that is, as what the primal phenomenon would look like if transposed from the domain of nature into that of history.[16] The moments of *Urgeschichte* (primal history) illuminated by the philosopher or writer are moments whose significance historically went unrecognised, and which are therefore in the process of disappearing from accounts of the past. In redeeming these moments, their connexion both to our present situation (as possibilities not followed through on) and to the future (as potential redemption for the present) can be made manifest. Using what he called 'dialectical images', examples of which Benjamin himself attempted to construct in *The Arcades Project*, the project of primal history opened up both the regressive elements of and the utopian possibilities within modern culture. In a well-known passage, Benjamin describes the dialectical image as 'that wherein what has been comes together in a flash with the now to form a constellation. In other words: the image is dialectics at a standstill . . . not temporal in nature but figural' (*AP*, 463; N3, 1). By extension, the (photographic) image might therefore be called a form of recollection that informs the present, or, given its flashlike nature, a kind of involuntary memory.

For Benjamin, Kafka is an exemplary constructor of dialectical images, of primal history. In 'Franz Kafka: On the Tenth Anniversary of his Death', Benjamin writes of the 'prehistoric forces that dominated Kafka's creativeness — forces which, to be sure, may justifiably be regarded as belonging to our world as well'.[17] He goes on to say that Kafka did not understand the significance of the dialectical images he constructed: 'Only this much is certain: he did not know them and failed to get his bearings among them. In the mirror which the prehistoric world held up to him in the form of guilt, he merely saw the future emerging in the form of judgement' ('FKO', 807). In other words, Kafka recognised only the failure, the condemnation, inherent in the dialectical images he constructed (Benjamin cites Kafka's characterisation of his present-day world as god's bad mood), and not their utopian intimations, at least not for the human race ('FKO', 798).

To anticipate our discussion of Kristeva's work, we might say that the prehistorical, or primally historical, which Benjamin names in

different places 'nature', 'the repressed', 'the unredeemed', 'the past before the Law and language', and 'dream images', might also be a cipher for the psychical unconscious. Indeed, in *The Arcades Project* Benjamin refers to a kind of collective unconscious, and his interest in Surrealism also testifies to his interest in the unconscious as a figure for both the primal past and a possible vision of the future. Rather than predating a point in linear time when history began to be recorded, the prehistorical antedates time and history per se; we might refer to it, following F. W. J. Schelling, as the time before time. As Freud repeatedly noted, the unconscious knows no time.

Benjamin writes of *Urgeschichte* in various contexts. In particular, in *The Arcades Project*, he is concerned with exposing moments of 'primal phenomena' that both illuminate an origin of the decline of a particular historical period, in this case the nineteenth century, *and* give an idea of how redemption might intervene as a vision in flashlike fashion out of these same moments. This can be compared to the way that the primal, ideal plant, in Goethe, can be glimpsed only out of the observation of its empirical unfoldings in physical specimens:

> I pursue the origin of the forms and mutations of the Paris arcades from their beginning to their decline, and I locate this origin in the economic facts. Seen from the standpoint of causality, however... these facts would not be primal phenomena; they become such only insofar as in their own individual development — 'unfolding' might be a better term — they give rise to the whole series of the arcade's concrete historical forms, just as the leaf unfolds from itself all the riches of the empirical world. (*AP*, 462; N2a,4)

Like Goethe, Benjamin viewed the primal phenomenon not as a chronological beginning or as a cause of a particular empirical phenomenon. Rather, the *Ur*-phenomenon posits the structural coherence of the whole — for Benjamin, in this case, the arcades as a figure for the nineteenth century but, for Goethe, all of nature. Nevertheless, Benjamin did not think this whole could ever be presented in its totality to human consciousness, at least not in modernity. Whatever primal history is, it can only be glimpsed in fragments, which is why it always preserves its flashlike temporality.

According to Benjamin, Goethe searched in vain for the primal phenomenon in nature. Because Goethe attempted to furnish empirical, scientific evidence for the primal phenomenon, 'the primal phenomenon as archetype (*Urbild*) too often turned into nature as model (*Vorbild*)'.[18] The difference between these two would be the difference between viewing a primal phenomenon as outside of time and as within time, namely, as a cause, whether in nature or in art. Benjamin writes that

> only in the domain of art do the *ur*-phenomena — as ideals — present themselves adequately to perception, whereas in science they are replaced by the idea, which is capable of illuminating the object of perception but never of transforming it in intuition. The *ur*-phenomena do not exist before art; they subsist within it. By rights, they can never provide standards of measurement. ('GEA', 315)

Thus the primal should not be confused with an origin that can be pinpointed in time; only artworks, which have the possibility of being transformed in intuition, may manifest these phenomena in a concrete sense.

In 'Paris, the Capital of the Nineteenth Century', Benjamin again discusses primal history, this time in terms of dreams, wishes, and the collective unconscious, in order to elucidate how this timelessness, or this existence outside of linear time, could be understood in terms of historical analysis. In the context of a discussion of the new technology, building materials, and means of production that were coming to be used and known, Benjamin remarks on the emergence of new 'wish images' in which 'the new is permeated with the old',[19] but where a desire is also expressed to leave everything antiquated behind:

> These tendencies deflect the imagination (which is given impetus by the new) back upon the primal past. In the dream in which each epoch entertains images of its successor, the latter appears wedded to elements of primal history [*Urgeschichte*] — that is, to elements of a classless society. And the experiences of such a society — as stored in the unconscious of the collective — engender, through

> interpenetration with what is new, the utopia that has left
> its trace in a thousand configurations of life, from enduring
> edifices to passing fashions. ('P', 33–4)

Here primal history refers to the idea of a 'classless society', realised at
no point in history, that nevertheless has been stored in the archaic past,
in a time before time (before consciousness), in the 'unconscious of the
collective'. The temporality of primal phenomena is one in which the
future nests in the past when seen from the perspective of the present.

Let us compare this to the way in which Benjamin discusses
the photograph in 'Little History of Photography'. Recall that the
photograph, too, has a flashlike temporality that is outside the linearity
of historical time, for it simultaneously indicates at least two moments:
a memory of the past that, like the lost or disappearing moment
of time that is redeemed in primal history, manifests a lineage
of what might have been. In the photograph of Dauthendey and
his fiancée, for example, a moment in the past emerges flashlike,
transformed in the perspective of the present, and indicating something
unconscious that suggests future events. This is also the temporality of
the dialectical image, which Benjamin connects to primordial history
in its relationship to historical time.

In order for the dream-image to have dialectical efficacy, it must
in some way have the capacity to influence the present or future. To
complicate matters further, Benjamin also speaks of capitalism itself,
that is, that which is *wrong* with modernity, as a dream. Hence the
dialectical image marks the efficacy of a dream-image in transforming
a dream and inducing a historical awakening. One might think of the
story of Sleeping Beauty, who awakens from dream/sleep at the end of
a story that itself is dream/fantasy.[20] This is what places the discussion
of the primal phenomenon within the realm of art, or perhaps even
of popular culture, despite the important political implications of
Benjamin's theory.[21] Benjamin argues that, like photography, this
process evokes a disruptive image rather than being historical is a
linear way. His aim was to construct images according to the theory
of montage, which he calls 'the art of citing without quotation marks'
(*AP*, 458; N1, 10). Only in such a manner, without linear continuity,
could the past 'touch' the present moment in the way we saw was
possible in the photograph (*AP*, 458; N 7, 7). Moreover, such a process

of 'construction' equally requires 'destruction' (*AP*, 458; N7, 6). Benjamin rejects the historian's attempt at a pure gaze into the past, 'without involving anything that has taken place in the meantime' (*AP*, 458; N 7, 5). The dialectician 'cannot look on history as anything other than a constellation of dangers which he is always, as he follows its development in his thought, on the point of averting' (*AP*, 458; N7, 2).

Because of this contiguity of past and present constructed in the dialectical image, the movement between them being precisely what constitutes the image as dialectical, the process described in both Benjamin's meditations on history and on photography can be called a mode of recollection. In 'On the Concept of History' Benjamin writes:

> The true image of the past flits by. The past can be seized only as an image that flashes up at the moment of its recognizability, and is never seen again ... it is an irretrievable image of the past which threatens to disappear in any present that does not recognise itself as intended in that image.[22]

What historical materialism, with which Benjamin associated himself, seeks to do is to appropriate 'a memory as it flashes up ... to hold fast that image of the past which unexpectedly appears to the historical subject in a moment of danger' ('OCH', 390–391). Like Kristeva, who, as we will see, privileges the foreign in its capacity to shake up the collective identity of the community, Benjamin prefers to linger with the fragmentary, seeing the totalising interpretation of history as an inevitable progression to be dangerous and misleading.

Benjamin judges Kafka's writing to be an attempt to enact precisely this form of recollection. He writes that 'Kafka's writing is simply full of configurations of forgetting — of silent pleas to recall things to mind'.[23] The forgotten assumes manifold forms. Kafka's work presents fragments of the forgotten, mingling those moments of primal history that have disappeared or are threatening to disappear from view and constructing new dialectical images. This amalgamation yields 'countless uncertain and changing compounds ... a constant flow of new, strange products' ('FKO', 810).

Kafka's 'Photography'

Adorno addresses this uncanny effect of Kafka's stories and images with an analogy to photography. He writes in a letter to Benjamin:

> I claimed [in an earlier interpretation of Kafka] he represents a photograph of our earthly life from the perspective of a redeemed life, one which merely reveals the latter as an edge of black cloth, whereas the terrifyingly distanced optics of the photographic image is none other than that of the obliquely angled camera itself. (*CC*, 66)

Weber Nicholson likens this comparison to a photograph of the earth from space, a figure that Adorno uses elsewhere (*EI*, 183).

As Nicholson points out, in considering photography Adorno is primarily interested in the photographer's gaze and the 'photographic negative' (a phrase he uses in his essay on Surrealism), that is, in the difference between what is photographed when it is observed in an ordinary way and when it is the object of a photographer's gaze. Benjamin, by contrast, is less concerned with the perspective of the photographer and concentrates primarily on what is photographed, both in terms of how it changes as a result of being photographed and what effect it has as a photograph (*EI*, 187), as well as the historical significance of the process of photography itself. The photograph's fidelity to nature has been called, by Rosalind Krauss, its indexical quality, whereas its iconic quality is its capacity to visually present a likeness (*OAG*, 203). While Krauss argues that what distinguishes photography from other forms of visual art is the 'absolute' relationship between these two qualities, such that the symbolic intervention that usually obtains between them is 'short-circuited' (*OAG*, 203), I would argue that Benjamin would see in photography at its strongest an ability to separate the iconic from the indexical quality. If photography is, for Benjamin, 'pre-symbolic', it would not be because, as Krauss claims, no Symbolic operations find their way into photographic art insofar as human consciousness makes a direct, Imaginary connexion between objects and their meaning in photographs (*OAG*, 203). It is 'pre-symbolic', rather, because photography has an intimate connexion to the optical unconscious and to the prehistorical, that place where a 'tiny spark of contingency' has 'seared the subject', such that in 'that

long-forgotten moment the future nests so eloquently that we, looking back, may rediscover it' ('LHP', 510).

Photography is the only art in which we may view the past with the exact eyes with which it viewed itself.[24] This does not imply, however, that to interpret history is to return to a specific point in time and reproduce it. In a section of 'Paralipomena to "On the Concept of History"' entitled 'The Dialectical Image', Benjamin argues that it is only in the future, in the touching of past and future, that history can be understood. He writes, citing André Monglond:

> If one looks upon history as a text, then one can say of it what a recent author has said of literary texts — namely, that the past has left in them images comparable to those registered by a light-sensitive plate. 'The future alone possesses developers strong enough to reveal the image in all its details.' ('OCH', 405)

To put it even more strongly, the truth of what revealed is not identical to the way in which it appeared at the time of its manifestation. The image's details must be developed in the way a negative is developed into a print, that is, with the technology (to continue the metaphor) that only the future holds. This is why Benjamin insists on a non-representational view of the truth of photography.

Adorno, by contrast, saw in photography and film an almost insurmountable temptation to be mimetic in the traditional sense of the word, that is, to faithfully represent what is portrayed. Nevertheless, his use of the photograph as a figure for Kafka's work casts an interesting light on the political role of art that seems to depend on at least a version of Benjamin's theory of photography.

Even now that photographs of the Earth taken from space are relatively common and cannot have quite the same striking effect as they must have the first time images of the planet from such a distant perspective appeared, we can still recapture, in thought, their uncanny effect. Such a photograph allows the future (space travel, remote photography) to touch the past (the familiar geography in which we have grown up). It literally makes what is most familiar, our home or *Heim*, unfamiliar, *unheimlich*. While we know that what we are looking at is literally the place that we are inhabiting at this very moment, we nonetheless feel it, *see* it, with a shock, as something outside of us.

Adorno's exposition of this metaphor comes from an unpublished draft of his Kafka essay that he refers to in a letter to Benjamin. He compares his position to Benjamin's position on theology, calling it an ' "inverse" theology' (*CC*, 67), or 'hell seen from the perspective of salvation' (*P*, 269). In a more distressing version of the earth from space image, Adorno writes that in the Middle Ages Jews were tortured and executed by being hung upside down; 'Kafka', he writes, 'photographs the earth's surface just as it must have appeared to these victims during the endless hours of their dying' (*P*, 269). Adorno goes on to call this form of 'artistic estrangement' one in which the world is seen as 'lacerated and mutilated' (*P*, 269), even though, as Elizabeth Pritchard notes, 'the standpoint of a resolute negativity is indistinguishable from the perspective of salvation — both reveal the world as hell' (Pritchard 2002, 308).[25]

In the version of the Kafka essay published in *Prisms*, Adorno compares the shock evoked by Kafka's writing to 'a surrealistic arrangement of that which old photographs convey to the viewer'.[26] He also notes the role of such a photograph in *The Castle*. In that work 'the fund of flash photographs is as chalky and mongoloid as a petty-bourgeois wedding by Henri Rousseau' (*P*, 256). Adorno's interpretation of Kafka's stories reveals their political implications. Like Benjamin, he sees these implications to be present in the stories, just as an image is present on a photographic plate; they are present but not yet capable of being developed except in a time beyond Kafka's own. In Kafka's stories, 'the social origin of the individual ultimately reveals itself as the power to annihilate him' (*P*, 253). Kafka's 'epic course' is 'the flight through man and beyond into the nonhuman' (*P*, 252). And maybe most strikingly: 'Perhaps the hidden aim of his art as a whole is the manageability, technification, collectivisation of the *déjà vu*' (*P*, 252). Here we gain a glimpse into the future by virtue of the recognition of what has already been: 'there are also images of what is coming, men manufactured on the assembly-line, mechanically reproduced copies...' (*P*, 253). Kafka 'unmasks monopolism by focusing on the waste-products of the liberal era that it liquidates' (*P*, 257). Like the view of the earth from space, Kafka's works reveal to us a picture of our most intimate lives that shocks in its apparent absurdity. His inverse theology ' "feigns" the divine or angelic standpoint in order to see the fallenness of the world' (Pritchard 2002, 309).

Adorno also compares Kafka work to expressionist art, calling it a translation of the practices of expressionist painting into literature (*P*, 264). This transfer allows Kafka's images to 'petrify into a third thing, neither dream, which can only be falsified, nor the aping of reality, but rather its enigmatic image composed of its scattered fragments' (*P*, 264). Benjamin and Adorno refer to the portrayal of this 'third thing' as 'mimesis', and they argue that Kafka's stories 'press toward the light' in order to manifest the third thing, the 'inexhaustible intermediate world' ('FKO', 810).

In the essay 'Surrealism: the last Snapshot of the European Intelligentsia' (note the photographic allusion in the title) Benjamin calls the surrealist movement, in this case the thought of André Breton, 'the first to perceive the revolutionary energies that appear in the "outmoded" — in the first iron constructions, the first factory buildings, the earliest photos'.[27] This capacity to convert things into energy 'consists in the substitution of a political for a historical view of the past' ('S', 210). Just as Surrealist literature and photography dissolve the things in which they appear, allowing them to release their energy, so too the surrealist emphasis on the dream 'loosens individuality like a bad tooth' ('S', 208). Benjamin focuses on the surrealist slogan 'to win the energies of intoxication for the revolution', but reinterprets intoxication as the perception of mystery in the everyday world and as the solitary reflection on 'that most terrible drug — ourselves' ('S', 216). Benjamin argues that the Surrealists are the only artists who have understood the 'present commands' of the *Communist Manifesto*: 'they exchange . . . the play of human features for the face of an alarm clock that in each minute rings for sixty seconds' ('S', 218). In this curious amalgam of human visage and clockwork, between dream and reality, we can discern both a critique of capitalism, which reduces the worker to a bit of machinery, and a redemptive possibility inherent in the idea of an alarm ringing out and the human gradually becoming a machine that in its last breath alerts the world to the danger it personifies.

Adorno writes of Surrealist dream-images:

> No one dreams that way. Surrealist constructions are merely analogous to dreams, not more. They suspend the customary logic and the rules of the game of empirical

evidence but in doing so respect the individual objects that have been forcibly removed from their context and bring the contents, especially their human contents, closer to the form of the object. There is a shattering and a regrouping, but no dissolution.[28]

At the same time, Adorno, like Benjamin, recognises the self-negating tendencies within Surrealism itself; surrealism, in realising itself, defeats itself. It is 'as witness to abstract freedom's reversion to the supremacy of objects and thus to mere nature', that Surrealist artists create true *nature morte* (*CI*, 89), images of commodity fetishes, mere things 'on which something subjective ... was once fixated' (think of the 'face' of the clock). In its collages and montages, Surrealism creates assemblages of dead things like 'mementos of the objects of the partial drives that once aroused the libido' (*CI*, 89). And 'as a freezing of the moment of awakening, Surrealism is akin to photography' (*CI*, 89):

> Not the invariant, ahistorical images of the unconscious subject to which the conventional view would like to neutralise them; rather, they are historical images in which the subject's innermost core becomes aware that it is something external, an imitation of something social and historical. 'Come on, Joe, imitate that old time music.' (*CI*, 89)

Again, these images are neither purely dream (internal) nor reality (external) but an amalgam of both. And Adorno's essay ends with a punch: 'if Surrealism itself now seems obsolete, it is because human beings are now denying themselves the consciousness of denial that was captured in the photographic negative that was Surrealism' (*CI*, 90).

What Surrealism accomplished, in Benjamin and Adorno's view, was a making strange of the familiar in such a way that it nonetheless evoked the feeling of 'Where have I seen that before?' (*CI*, 88) This is the feeling of seeing earth from space, resulting in the affect peculiar to the uncanny. Surrealism makes manifest the uncanny way in which the things nearest to us, those that seem most animated, have become dead things, the way in which what we think of as closest to ourselves may somehow be most alienated from us.

Kristeva: Art as Revolt

I argue that what some photographic artworks achieve is a momentary incision into the patterns of everyday imaginary life, opening up a vision of something to which one would otherwise never have had access. Julia Kristeva's notion of art as revolution posits an analogy between the process that takes place in the psychoanalytical situation — in which, through discourse, repressed memories may be reawakened and sedimented psychic patterns may be exposed and perhaps reoriented in a healthier way — and artworks that repeat in such a way that they open up new possibilities. In particular, the poetic artwork may incorporate elements of what Kristeva calls the semiotic mode of language, which explicitly manifests its connexion back to the origins of linguistic acquisition, foregrounding pre-symbolic elements of language like rhythm, intonation, and alliteration, which accompany and enhance signification but do not themselves signify, and which are related to the primary unconscious psychical processes of condensation and displacement.[29]

Revolution, or revolt, which Kristeva understands in reference to its Latin root *volere*, suggests a turning, uncovering, discovering that would prompt a reconsideration of the role of poetic language, specifically in terms of its possibility of effecting a renovation of the way in which we think of the constitution of language, its role in the constitution of the subject, and the ways in which subjects and language itself can be transformed through a new kind of language that foregrounds pre-symbolic elements without completely reverting to them.

All efforts to create, Kristeva implies, may be attempts to rediscover a lost unity, a plenitude that disappeared with our individuation as subjects. As she remarks in her essay on Giovanni Bellini, reunion with the mother, or re-experience of our first experience of fulfillment, is impossible, but remains a fantasy: 'Maternal space is there, nevertheless — fascinating, attracting, and puzzling. But we have no direct access to it.'[30] Art is a way of accessing the impossible, the maternal space, creating a 'perverse object' in order to escape from the incapacity to express, in order to 'experience the infectious auto-eroticism we encounter when we construct a sensory fiction'.[31] At the same time, the experience of maternity is also one in which something like the space that art opens up for us can be experienced, a space that Kristeva

calls a limit or threshold between language and the drive, between the symbolic and the semiotic (*DL*, 240).

The catalogue for a 2000 exhibition of photography at the BildMuseet in Sweden curated by Alfredo Jaar contains an interview with Kristeva entitled 'The Paradise of the Mind'.[32] Here Kristeva discusses the photographs in the exhibit, all taken by leading international photojournalists, which depict for each individual the most desperate and painful scene they had ever captured, juxtaposed with the most hopeful and joyful, in an exhibit entitled 'Inferno/Paradiso'. Referring to the Arendtian conception of natality, itself taken from St. Augustine's notion of second birth, Kristeva discusses 'the very character of human existence in the world' as 'the repetition of the *principium* [God's creation of the world]', a 'definition of freedom as self-beginning'. Here we see that what could be conceived of as a return to the mother through art is actually a kind of second birth, a birth to self-expression and self-reliance that repeats (in a way that revolutionises) the initial creative act. The interviewer quotes from Kristeva's essay in the catalogue for the Louvre exhibition *Visions Capitales*, in which she calls the image 'perhaps our only remaining bond to the sacred'.[33] As such, the image interrupts, re-organises, and provides the condition for the possibility of a 'second birth'.

Kristeva's conception of the role of the image and poetic language relates in its function to Jacques Lacan's 'The Function and Field of Speech and Language in Psychoanalysis'. In this essay Lacan discusses his controversial introduction of the notion of a psychoanalytic session of unfixed duration as a means of disrupting the analysand's expected psychic patterns in the session. Lacan refers to the tempo, duration, and ultimately signification of a session, just as of a sentence, as its 'punctuation':

> The ending of a session cannot but be experienced by the subject as a punctuation of his progress. We know how he calculates the moment of its arrival in order to tie it to his own timetable, or even to his evasive maneuvers, and how he anticipates it by weighing it like a weapon and watching out for it as he would for a place of shelter.
>
> It is a fact, which can be plainly seen in the study of manuscripts of symbolic writings, whether the Bible or the

> Chinese canonical texts, that the absence of punctuation in them is a source of ambiguity. Punctuation, once inserted, establishes the meaning; changing the punctuation renews or upsets it; and incorrect punctuation distorts it.[34]

By changing the duration of a session, in particular through the instantiation of 'short sessions', Lacan hoped to disrupt the expectations of his patients and give birth to new revelations from the repressed unconscious of his patients. Indeed, he gives as evidence of the success of this method the following statement: 'I was able to bring to light in a certain male subject fantasies of anal pregnancy, as well as a dream of its resolution by Cesarean section, in a time frame in which I would normally still have been listening to his speculations on Dostoyevsky's artistry' (*E*, 259). Lacan relates this technique to the effect of punctuation on an interpreted text. Such 'punctuation' (from *punctus*, or 'prick') interrupts, reorganises, and in the best of cases renews or refreshes the significance of that text, signaling a 'new birth' in interpretation.

Art has an analogous capacity to disrupt meaning and suggest new configurations through its innovation in punctuation, and it is this capacity that Kristeva refers to as its possibility of 'inscription' rather than representation. In *Crisis of the (European) Subject* and in the catalogue for *Visions Capitales*, Kristeva explores what she calls, following Merleau-Ponty, a play between the visible and the invisible, through a contrast of the Catholic and Orthodox traditions of Christianity in Europe. One of the causes of the split between the Eastern Orthodox and the Roman Catholic Church was that the latter was perceived by the former to worship idols. Kristeva contrasts the image or representation, as it flourished in Catholic art, with the Orthodox icon of Byzantium. She focuses on a peculiar brand of iconoclasm functioning as the equivalent of Freudian negation in that it allows for some imaginary element to be manifest that would otherwise remain hidden, by virtue of the ban on images.

Kristeva links the concept of inscription to the Byzantine visual economy of the icon, where the divine is manifest in terms of a sensible trace rather than an image. The iconic tradition is related to accounts of the so-called mandylion of Abgar, a piece of cloth upon which the face of Jesus was said to be imprinted (unlike the shroud

of Turin, the imprint is of a face alone, and was said to have been sent in life in a letter from Jesus to King Abgar of Edessa in response to a request for healing). The important facet of the mandylion that Kristeva emphasises is that it is an imprint, or indication, rather than a representation of Christ's face.

The clearest examples of contemporary art that follow the logic of Kristeva's notion of the artistic return of the repressed under the sign of negation are those that take as their subject a traumatic political event in the past and our current relation to it. What Kristeva's articulation of an avant-garde art of inscription, Benjamin's notion of a flash-like temporality that severs an image from its context in a linear narrative, and Barthes's conceptualisation of the punctum, or punctual node of a photograph, have in common is the idea of art as a cutting away or through. Certain artworks can be understood in this way even though they do not always, as in the art of Lucio Fontana (an artist Kristeva references), literally use cutting as an artistic form.[35] The word in French for 'to cut' is *couper*, at the root of both *tout d'un coup*, the phrase in Proust that so often signals the narration of the instant of the emergence of involuntary memory, and *après coup*, the French translation of Freud's *Nachträglichkeit*. It is this notion of revolt or return through severing that characterises the kind of art that, for Kristeva, signals a political repetition through difference.

To call this kind of return and rebirth a primal phenomenon is not inappropriate, given the importance Kristeva accords to the maternal relationship and to the semiotic underbelly of symbolic life. For Goethe, the primal phenomenon was both an archetype and an ideal, both origin and goal, of the natural entity; he even refers to it, in one poem, as a primal mother.[36] It may be helpful to illustrate this idea with references to some examples from contemporary photography.

Punctuation/Cutting/Inscribing in Contemporary Photography
The attraction of contemporary photographers to the idea of the Goethean *Urpflanze*, or primal plant, is striking. The first example to come to mind is the early twentieth century photographer Karl Blossfeldt, whose plant photographs he himself named 'primal forms of nature'. Specifically inspired by Goethe's studies of the metamorphosis of plants and search for the primal plant, Blossfeldt photographed greatly magnified parts of plants in the way that Atget photographed

architectural forms, isolating them from the context of a whole in such a way that one sometimes cannot tell if the form presented is natural or humanly fashioned. In his review of *Primal Forms of Art: Photographic Images of Plants*, Benjamin writes that Blossfeldt has both recorded and transformed the human image of the world through his magnification of our perspective on everyday phenomena.[37] As in his discussion of the new capacities of photography and film, Benjamin writes 'whether we accelerate the growth of a plant through time-lapse photography or show its form in forty-fold enlargement, in either case a geyser of new image-worlds hisses up at points in our existence where we would least have thought them possible' ('NF', 156). This 'hissing up of new image-worlds' is a form of punctuation that can potentially stimulate the re-imagination of the world.

A more recent, parallel example can be found in the photography of Robert Bueltman, who runs an electric current through plant forms in order to reveal them in an unearthly, uncanny blue light that seems to most intensely manifest their life force even in the midst of a process that will destroy them.[38] Artist Sonya Rapoport takes a different approach, using the plant photographs of Imogen Cunningham in tandem with quotations from a feminist critique of Goethe's botanical studies.[39] Something about the plant form, both in its apparent purity and innocence, and in its mirroring of architectural, human-created forms, seems to cause a primal response in the human imagination. Benjamin muses as to what Blossfeldt might have meant in calling his photographic images of plants *Ur-formen*, or primal forms, and answers that they are 'forms . . . which were never a mere model for art but which were, from the beginning, at work as originary forms in all that were created' ('NF', 156). Explicitly comparing Blossfeldt's plant images to architectural forms, Benjamin sees in the primal form 'inner image-imperatives [*Bildnotwendigkeiten*], which have the last word in all phases and stages of things conceived as metamorphoses', that is, of all things natural and artistically creative, the 'creative collective', the 'feminine and vegetable principle of life' ('NF', 156–157). Perhaps successful photography always provides a glimpse of this principle or image-imperative.

But it is the work of the Colombian artist Juan Manuel Echavarría, in particular the series and exhibition entitled *Corte de Florero*, or the Flower Vase Cut, that manifests this phenomenon most strikingly. In

this series, whose title makes a veiled political reference, Echavarría foregrounds the flower vase cut, one of the mutilations practiced during the Columbian violence of the 1940s. The series depicts elaborate and beautiful botanical specimens constructed entirely out of human bones. The photographs recall botanical drawings recorded by European explorers who wanted both to document new species of plants and to entice European viewers in an attempt to encourage colonisation and inhabitation of the 'new world'. Scientific curiosity and violent conquest are thus juxtaposed, just as the fragile beauty of the plant is presented simultaneously with the horror of human remains. Describing his work in this series, Echavarría writes: 'My purpose was to create something so beautiful that people would be attracted to it. The spectator would come near it, look at it, and then when he or she realises that it is not a flower as it seemed, but actually a flower made of human bones — something must click in the head, or in the heart, I hope'.

It is this 'click' that I think draws together Kristeva's art of inscription (from the Greek *skariphasthai*, 'to scratch an outline'), Lacan's punctuation, and Benjamin's theory of photography. What can come to presence in such an artwork is not a narrative or a message but, perhaps, only an image cut off from its original context. When the camera 'clicks', it severs a moment from the flow of linear time and isolates it in space, resulting in a presented moment that can be returned to immediately, after a long-deferred stretch of time, or never. The isolation of a moment or moments can have the effect of estranging us from our ordinary sequence of experiencing, considering or recalling events, resulting in an insight into them that was previously unavailable or inaccessible, a photograph as primal phenomenon.[40]

Notes

[1] For further reading on Benjamin and photography, see Diarmuid Costello, 'Aura, Face, Photography: Re-Reading Benjamin Today', in *Walter Benjamin and Art*, ed. Andrew Benjamin (New York and London: Continuum Press, 2005), 164–84; David Ferris, 'The Shortness of History, or Photography in Nuce: Benjamin's Attenuation of the Negative', in *Walter Benjamin and History*, ed. Andrew Benjamin (New York and London: Continuum Press: 2005), 19–37; and Nicholson, Shierry Weber, 'Adorno and Benjamin, Photography and the Aura', in

Exact Imagination, Late Work: On Adorno's Aesthetics (Cambridge, MA: The MIT Press, 1997). Hereafter Nicholson's article will be referenced in the text as *EI*.

2 Walter Benjamin, 'Little History of Photography', in *Selected Writings*, Volume 2, 507–530 (Cambridge, MA: Harvard University Press, 1999), 507. Hereafter cited within the text as 'LHP', followed by page number(s).

3 Walter Benjamin, 'The Work of Art in the Age of its Mechanical Reproducibility,' in *Selected Writings*, Volume 4, 251–283 (Cambridge, MA: Harvard University Press, 2002), 254. Hereafter cited as 'WA', followed by page number(s).

4 For more on this comparison, see Benjamin, 'On the Image of Proust', in *Selected Writings*, Volume 2, 237–247 (Cambridge, MA: Harvard University Press, 1999). Here Benjamin also calls Proust the only writer to reveal correspondences in our everyday life (244).

5 Sigmund Freud, 'Moses and Monotheism', in *The Penguin Freud Library*, Vol. 13, *The Origins of Religion*, trans. James Strachey (London and New York: Penguin Books, 1953).

6 'With the close-up, space expands; with slow motion, movement is extended. And just as enlargement not merely clarifies what we see indistinctly "in any case", but brings to light entirely new structures of matter, slow motion not only reveals familiar aspects of movements, but discloses quite unknown aspects within them …' ('WA', 265–66).

7 See Elaine P. Miller, 'Negativity, Iconoclasm, Mimesis: Kristeva and Benjamin on Political Art', *Idealistic Studies* 38:1–2 (2008), 55–74 for more on this subject.

8 Walter Benjamin, 'On the Mimetic Faculty', in *Selected Writings*, Volume 2 (Cambridge, MA: Harvard University Press, 1999), 722. Hereafter cited as 'OMF', followed by page number(s).

9 Barthes, '*Rhetorique de l'image*', cited in Rosalind Krauss, *The Originality of the Avant-Garde and Other Modernist Myths* (Cambridge, MA: MIT Press, 1984), 217–18. Hereafter cited within the text as *OAG*, followed by page number(s).

10 In a letter to Benjamin from August 1935 Adorno claims there is an 'exact correspondence' between painting's flight from photography in the nineteenth century and music's flight from 'banality'. See *The Complete Correspondence, 1928–1940*, trans. Nicholas Walker (Cambridge, MA: Harvard University Press, 1999), 110. Hereafter cited within the text as *CC*, followed by page number(s).

11 While Adorno's commentary on Benjamin's 'Little History of Photography' and his essays on Kafka demonstrate that Adorno valued the metaphor of the photographic negative as a way of thinking about redemptive art, it is unclear that he would say the same of actual photographs.

[12] Theodor W. Adorno, *Aesthetic Theory*, trans. Robert Hullot-Kentor (Minneapolis: University of Minnesota Press, 1997), 31. Hereafter cited within the body of the text as *AT*, followed by page number(s).

[13] Letter of 17 December 1934, from Theodor Adorno and Walter Benjamin (*CC*, 66).

[14] Theodor W. Adorno, *Negative Dialectics*, trans. E.B. Ashton (New York and London: Continuum, 2005), 205.

[15] Benjamin cites Baudelaire's 'On Photography' to the effect that 'in these sorry days, a new industry has arisen that has done not a little to strengthen the asinine belief... that art is and can be nothing other than the accurate reflection of nature.... A vengeful god has hearkened to the voice of this multitude. Daguerre is his Messiah' ('LHP', 527, cited seemingly mistakenly as coming from the *Salon of 1857*; Baudelaire's essay 'On Photography' appeared in the *Salon of 1859*, first published in the *Revue Française*, Paris, June 10–July 20, 1859, and can be found in translation in *Charles Baudelaire, The Mirror of Art*, ed. and trans. Jonathan Mayne (London: Phaidon Press Limited, 1955).

[16] Walter Benjamin, *The Arcades Project*, trans. Howard Eiland and Kevin McLaughlin (Cambridge: Harvard University Press, 1999), 462; N2a4. Hereafter cited within the text as *AP*, followed by page and section number.

[17] Walter Benjamin, 'Franz Kafka: On the Tenth Anniversary of His Death', in *Selected Writings*, Volume 2 (Cambridge, MA: Harvard University Press), 807. Hereafter cited within the text as 'FKO', followed by page number(s).

[18] Walter Benjamin, 'Goethe's Elective Affinities', in *Selected Writings*, Volume 1 (Cambridge: Harvard University Press, 1996), 315. Hereafter cited within the body of the text as 'GEA', followed by page number(s).

[19] Walter Benjamin, 'Paris, the Capital of the Nineteenth Century', in *Selected Writings*, Volume 3 (Cambridge, MA: Harvard University Press, 2002), 33. Hereafter cited as 'P', followed by page number(s).

[20] For a more in-depth discussion of the fairy tale motif in Benjamin, see Susan Buck-Morss, *The Dialectics of Seeing: Walter Benjamin and the Arcades Project* (Cambridge, MA: MIT Press, 1989), especially Chapter 8.

[21] Buck-Morss (1989) writes that Benjamin's 'theory is unique in its approach to modern society because it takes mass culture seriously not merely as the source of the phantasmagoria of false consciousness, but as the source of collective energy to overcome it' (253).

[22] Walter Benjamin, 'On the Concept of History', in *Selected Writings*, Volume 4 (Cambridge, MA: Harvard University Press, 2003), 390–1. Hereafter cited as 'OCH', followed by page number(s).

23 Walter Benjamin, 'Franz Kafka: *Beim Bau der Chinesischen Mauer*', in *Selected Writings*, Volume 2 (Cambridge, MA: Harvard University Press, 1999), 498. Hereafter cited within the text as 'FKB', followed by page number(s).

24 See Ferris 2005.

25 Elizabeth Pritchard, '*Bilderverbot* meets body in Theodor Adorno's Inverse Theology', *Harvard Theological Review* (2002), 95:3, 291–318.

26 Theodor W. Adorno, *Prisms*, trans. Samuel and Shierry Weber (Cambridge, MA: The MIT Press, 1967), 253. Hereafter cited within the body of the text as *P*, followed by page number(s).

27 Walter Benjamin, 'Surrealism: The Last Snapshot of the European Intelligentsia', in *Selected Writings*, Volume 2 (Cambridge, MA: Harvard University Press, 1999), 210. Hereafter cited as 'S', followed by page number(s).

28 Theodor W. Adorno, *The Culture Industry: Selected Essays on Mass Culture*, ed. J. M. Bernstein (London: Routledge, 1991), 87. Hereafter cited within the text as *CI*, followed by page number(s).

29 See Julia Kristeva, *Revolution in Poetic Language*, trans. Leon S. Roudiez (New York: Columbia University Press, 1984).

30 Julia Kristeva, *Desire in Language,* ed. Leon S. Roudiez (New York: Columbia University Press, 1980), 247. Hereafter referred to as *DL*, followed by page number(s).

31 Julia Kristeva, *Time and Sense: Proust and the Experience of Literature*, trans. Ross Guberman, (New York: Columbia University Press, 1996), 241.

32 'The Paradise of the Mind,' an interview with Rubén Gallo, in *Paradiso/Inferno*, catalogue for photography exhibit curated by Alfredo Jaar. Stockholm: Riksutställningar (unpaginated).

33 Julia Kristeva, *Visions Capitales* (Paris: Editions de la Réunion des musées nationaux, 1998).

34 Jacques Lacan, *Écrits*, trans. Bruce Fink (New York: W.W. Norton, 2002), 258. Hereafter cited as *E*, followed by page number(s).

35 Kristeva says of Fontana's art: 'he is inviting us to a participation in the visible that is not limited to the gaze alone but engages our entire affectivity. The icon's oscillation between visible and invisible is thus unconsciously sought.' Julia Kristeva, *Crisis of the European Subject,* trans. Susan Fairfield (New York: Other Press, 2000).

36 Goethe used the image of the *Ur*-mother giving birth to a fully formed series of creatures in a poem entitled 'Metamorphosis of Animals' (1806). See Johann Wolfgang Von Goethe, *Scientific Studies*, ed. and trans. Douglas Miller (New York: Suhrkamp Publishers, 1988).

[37] Walter Benjamin, 'News About Flowers', in *Selected Writings*, Volume 2 (Cambridge, MA: Harvard University Press, 1999), 155. Hereafter cited as 'NF', followed by page number(s).

[38] See Jason Alber, 'Force of Nature: Artist Puts Petal to the Metal for Electrifying Images', *Wired* Magazine 17:07, 22 June 2009, online at http://www.wired.com/culture/art/magazine/17-07/pl_art, consulted 1 March 2010.

[39] See http://sonyarapartblog.blogspot.com/2008/10/golden-links-in-goethesalchemical.html, consulted 1 March 2010.

[40] The final version of this paper is indebted to the incredibly helpful feedback that I received when it was first presented at the DePaul University Graduate Student Conference in 2008, in particular from Michael Naas, and also from Sina Kramer, Dilek Hüseyinzadeğan, Joe Weiss, and all the graduate students in attendance at my talk.

Dark Room Readings: Scenes of Maternal Photography

Elissa Marder, *Emory University*

> The impossible sometimes, by chance, becomes possible: as a utopia.
> Jacques Derrida, 'The Deaths of Roland Barthes'[1]

> I had the impression that, by focusing on these words like a photograph, one could — and the analysis would be endless — discover within them so many 'things' that their letters showed by concealing themselves, remaining [*demeurant*] immobile, impassive, exposed, too obvious, although suspended in broad daylight in some dark room, some *camera obscura* of the French language, Jacques Derrida, *Athens, Still Remains*[2]

Keywords: Barthes, Derrida, Freud, Cixous, photography, Proust, mother, maternal body, utopian time, involuntary memory.

I: Second Sight: the Photographic Maternal (Barthes)

In one of the rare important passages of *Camera Lucida* that has not yet been subjected to extensive critical scrutiny, Roland Barthes invokes Baudelaire, Freud, and the maternal body in the same breath as part of a meditation on Charles Clifford's 1854 photograph 'Alhambra'.[3] Barthes's discussion of the 'Alhambra' photograph takes place in chapter 16 of *Camera Lucida* and appears at first glance to be no more than a simple illustration of his declared preference that landscapes ought to be places one desires to inhabit rather than places one wants to visit. As he contemplates Clifford's nineteenth century image of an ancient Mediterranean urban landscape and wonders why it elicits such

The Oxford Literary Review 32.2 (2010): 231–270
Edinburgh University Press
DOI: 10.3366/E0305149810000775
© The Oxford Literary Review
www.eupjournals.com/olr

a powerful feeling of familiarity in him, he produces this remarkable gloss on his own response to the image:

> This longing to inhabit, if I observe it clearly in myself, is neither oneiric (I do not dream of some extravagant site) nor empirical (I do not buy a house according to the views of a real estate agency); it is fantasmatic, deriving from a kind of second sight which seems to bear me forward to a utopian time, or to carry me back to somewhere in myself: a double movement which Baudelaire celebrated in '*Invitation au voyage*' and '*La Vie antérieure*'. Looking back at these landscapes of predilection, it is as if I *were certain* of having been there or going there. Now Freud says of the maternal body that 'there is no other place of which one can say with so much certainty that one has already been there.' Such then would be the landscape (chosen by desire): *heimlich*, awakening in me the Mother (and never the disturbing Mother). (*CL*, 40)

This deceptively simple passage demands to be read closely and calls for careful thinking. Indeed, the more closely one looks at it, the stranger it becomes. Paradoxically, this is so in part because it presents itself so emphatically (at every level) under the sign of the 'familiar'. After all, this chapter of the book is explicitly devoted to landscapes, home, and the mother: all three of these figures are arguably the very defining principles of 'Nature', the natural, and the familiar. Read in this way, Barthes here is simply indulging in a nostalgic longing to return to the known and knowable comforts of home where the biographically familiar and biologically natural mother will watch over him. Such a reading implicitly assumes that Barthes's references to the language of poetry (via Baudelaire) and that of psychoanalysis (via Freud) are merely instrumental (or ornamental) and need not be taken overly seriously. Thus many (if not most) readers interested in the larger historical, political, philosophical, aesthetic, and deconstructive stakes of Barthes's reflections on photography simply skip over this moment in the text, preferring to ruminate instead on the seductive powers of the *punctum* and the elusive aura of the Winter Garden Photograph. Moreover, even for those readers who do take the time to look at it more

Figure 1. Charles Clifford, The Alhambra (Grenada), 1854–1856.

closely, this passage presents special difficulties as it is tempting to read it (and it almost asks to be read thus) according to a number of very familiar conceptual paradigms. Among the more compelling readings that have been proposed we tend to find variations on the following themes: 1) a regressive (mythical) fantasy of a return to the (lost) and mourned biographical mother; 2) a poetic expression of the powers of the imagination in the articulation of desire; 3) an engagement with Freud's 'Uncanny' essay as a way of thinking about photography's inherently canny/uncanny relation to the referent, the natural world, and with it the body of the mother and the *noeme* of photography; 4) a perverse (incestuous and murderous) relation to the maternal body accompanied by a fetishistic denial of the mother's death.

Barthes's text certainly supplies ample evidence to support all of these approaches. Several critics have offered particularly convincing and sophisticated accounts to explain why Barthes insists upon claiming that the 'Mother' about whom he writes here is purely

'*heimlich*' despite the fact that he knows perfectly well that such a designation verges on the meaningless, the mad or the perverse because, according to the very logic of the text by Freud to which he alludes here, the word '*heimlich*' (meaning 'comforting familiar') can never be fully dissociated from its disturbing, unfamiliar opposite: '*Unheimlich*'.[4] While I do not want to contest the validity of any of these readings, I do want to suggest that they may not have fully accounted for some of the most far-reaching uncanny insights of this passage in Barthes's book. As we shall see in a moment, Barthes's handling of this photograph is critical to any reading of *Camera Lucida* not merely because of *what* he claims to find in the 'Alhambra' landscape image (i.e., the '*heimlich*' maternal body) but also, more radically, because of *how* he reads the image: photographically.

Although I hope to draw out some of the implications of this photographic reading process in the pages that follow, for the moment I would merely like to sketch out briefly the structure of the reading process as he describes it in the passage cited above. He recounts how he turns his gaze inward and observes himself recollecting certain textual images that come to him through the language of poetry (via two poems by Baudelaire) and dream-like text-images that come to him through the language of psychoanalysis (via the quotation from Freud). On the basis of his internal reproduction of all these images in the dark reading room of the psyche, he produces a new kind of image ('*fantasmatic*') derived from a new kind of psychic image-writing technology ('*second sight*') that enables him to conjure up a new kind of temporality ('*utopian time*'). Barthes does not exactly seem to read the photograph; instead, the photograph reads him. It retrieves a latent image from an immemorial past within him and returns it to him as a timeless (or '*utopian*') image of his desire. The entire process is explicitly figured as a quasi-photographic operation that opens up onto a complex reflection on temporality, language, and an alternative (non-referential) conception of writing history.

But we are not there yet. If, for now, we take out a magnifying glass to look in greater detail at how Barthes treats Clifford's photograph in his own text, we find that the image in question starts to look even stranger still. He provides little or no specific commentary about any of the visual or photographic qualities of the photograph as such. Instead of writing *about* the image, he writes *on* it, inscribing it

with diverse kinds of written texts, thereby transcribing the visual components of the image into a new composite form of writing. As it figures in Barthes's text, Clifford's photographic image turns into a word-picture composed of various elements, both visual and verbal, which he carefully assembles and puts into meaningful relation with one another. The most obvious visible elements of this picture-puzzle are: the 'original' photographic image; the identifying textual markers for the photographic image ('Charles Clifford: Alhambra (Grenada) 1854–1856'); the caption, written by Barthes, that is inscribed under the image: '*C'est là que je voudrais vivre . . .*' ['It is there that I would like to live' (translation modified)][5]; the titles of two poems by Charles Baudelaire ('*Invitation au voyage*' and '*La Vie antérieure*'), an allusion to Freud's conception of the maternal body as primal dwelling place presented via an (unidentified) sentence fragment of Freud's writing. This 'fantasmatically' constructed composite photo-word picture operates within Barthes's text both as gloss of the 'original' photograph by Clifford and as a new, quasi-photographic lexical reproduction that must now be read on its own terms. But what kind of an image is this and how is it to be read given that it is not, strictly speaking, 'visible' to the naked eye? This image only becomes legible through acts of reading. Barthes himself signals its special status by gesturing toward the need for a new critical vocabulary to describe its dreamlike formal consistency and its unique (albeit virtual) powers through his use of the descriptive qualifiers: '*fantasmatic*', '*second sight*' and '*utopian*'.

Indeed, the composite structure of this fantasmatic photo-text resembles something analogous to Freud's famous description, in *The Interpretation of Dreams*, of the 'poetical phrases' of the picture-puzzle rebus that are the stuff from which dreams are made. Freud describes how the rebus should be read as follows:

> If we attempted to read these characters according to their pictorial value instead of according to their symbolic relation, we should clearly be led into error. Suppose I have a picture-puzzle, a rebus, in front of me The words which are put together in this way are no longer nonsensical but may form a poetical phrase of the greatest beauty and significance. A dream is a picture-puzzle of this sort. (*The Interpretation of Dreams*, *SE*, IV, 277–8)

As is well known, this description of the dream as a 'picture-puzzle' (or a rebus) occurs at the beginning of Chapter VI of the *Interpretation of Dreams* where Freud introduces the complex signifying operations that constitute the dream-work. I would like to suggest a comparison between Barthes's 'fantasmatic image' and Freud's dream rebus in this context for several reasons. First, I would like to call attention to the fact that Barthes's 'fantasmatic' image (like the picture-puzzle described by Freud) demands to be actively read and interpreted precisely because its meaning is *not* located at the level of mimetic referential representation. Like the dream rebus, the 'fantasmatic' photographic image constitutes its meaning by *how* it speaks — according to the laws of its own strange signifying system derived from the relations among its various elements — rather than by *what* it depicts. For Freud, dream images come from the past, but they do not belong to it. Dreams are not representations; they are psychic elaborations of (repressed) material from the past that is worked over in the dark room of the psyche and then brought to light in the ('*utopian*') timeless time of the dream image. It is worth recalling here that Barthes initially defines the fantasmatic image through *negation* by comparing it to what it is *not*: he specifies that it is neither '*oneiric*' nor 'empirical'. Indeed, the very designation 'fantasmatic' itself emerges, within Barthes's text, as a kind of fantasmatic dialectical resolution (or *Aufhebung*) — it springs forth as a new third term that materializes out of the negative relation between the '*oneiric*' and the 'empirical,' i.e. between dream image and referential representation. Moreover, the relation between the virtual possibilities normally attributed to the '*oneiric*' dream image and the referential certainty normally ascribed to the realm of the 'empirical' determine and haunt this passage in other significant ways as well.

This strange relation that Barthes establishes (between dream image and referential certainty) becomes somewhat more legible if we take a closer look at the sentence-fragment by Freud that Barthes quotes in this passage. Leaving aside the titles of Baudelaire's poems, this fragment is the only direct quotation in this chapter of Barthes's book. The source of the fragment in question comes verbatim from the *Interpretation of Dreams* and not, as has been assumed by many of Barthes's readers, from the much later 'Uncanny' essay — although, as we shall see, Freud himself essentially photocopies his own earlier passage from the dream book and reproduces it (with some slight

differences) in that later text.[6] The words Barthes attributes to Freud are the following: 'there is no other place of which one can say with so much certainty that one has already been there.' But if we now take a closer look at the context in which these words appear in the *Interpretation of Dreams* and read them back through Barthes's discussion of landscape photography and its relation to the 'fantasmatic image,' both texts — Barthes's and Freud's — begin to look even stranger. Here is the passage from in the *Interpretation of Dreams*:

> In some dreams of landscapes and other localities emphasis is laid in the dream itself on a convinced feeling of having been their once before. (Occurrences of *déjà vu* in dreams have a special meaning.) These places are invariably the genitals of the dreamer's mother; there is indeed no other place about which one can assert with such conviction that one has been there once before. (*The Interpretation of Dreams*, [1900] SE, V.5, 399)

Freud's text is, quite simply, astonishing. He begins with the fairly unremarkable observation that dreams of landscapes often awaken a particular feeling of familiarity in the dreamer. From there, however, he goes on to relate the particular feeling of familiarity (as it is 'lived' in *dreams*) to the occurrence of '*déjà vu*' (as it is experienced in *dreams*) and then goes on to conclude (on the basis of the evidence provided by these unique instances of 'fantasmatic dream images') that these exceptional dream experiences (unlike the normal kinds of dream-images discussed above) are actually memory traces of a real, lived, former existence in the mother's body and that, as such, they bear witness to the primal and foundational 'certainty' of that former life and, along with it, of the event of our birth. Put another way, Freud here seems to suggest that when the experience of '*déjà vu*' occurs in dreams, (as opposed to 'lived life') it does not function like a dream image at all, but more like some kind of psychic 'photograph' that provides quasi-referential evidence to support the 'certainty' that we have once inhabited the body of the mother.

It is important to recognize how truly strange this argument is even within Freud's own conceptual framework. For Freud, ordinary experiences of '*déjà vu*' in conscious, waking life *do not* mean that

one has actually seen something before; on the contrary, he explains such feelings as benign distortions of reality that are determined by unconscious subjective desires and fears.[7] Here, however, he argues something very different altogether. He suggests that when the experience of '*déjà vu*' occurs in dreams, it is the *mechanical reproduction* of an impossible image (the image of our birth) that was seen (but not by any subjective presence) without having been seen. '*Déjà vu*' in dreams really means that something real was 'always already seen before': the very fact of the repetition and reproduction of the image appears, paradoxically, to guarantee the unique status (in time and place) of the event that it ostensibly repeats. In this sense, the reproduction of the image through the dream resembles something like a 'photographic reproduction' of an un-photographable event.

And all of this, it would seem, is made possible by a fantasmatic dream image that passes through the dark room that is the maternal body.[8] Given the strange and uncanny convergence between 'dream image' and 'unique certainty' of the reality of a former life that cannot be recalled, it is no wonder that Freud returns to the uncanny properties of the maternal body in his essay on 'The Uncanny.' There, he writes:

> It often happens that neurotic men declare that they feel that there is something uncanny about the female genital organs. This *unheimlich* place, however, is the entrance to the former '*Heim*' [home] of all human beings, to the place where each one of us lived once upon a time and in the beginning. There is a joking saying that 'Love is home-sickness'; and whenever a man dreams of a place or a country and says to himself, while he is still dreaming: 'this place is familiar to me, I've been here before', we may interpret the place as being the mother's genitals or her body. [Here Freud inserts a footnote to his own prior text in *The Interpretation of Dreams*.] In this case too, then, the *unheimlich* is what was once *heimish*, familiar; the prefix '*un*' ['un'-] is the token of repression. 'The Uncanny', [1919] *SE*, V. XVII

There is something uncanny about the relationship between this passage about the uncanny status of the female genitals from 'The Uncanny' essay and the earlier text about the feeling of *déjà vu* in landscape dreams from the *Interpretation of Dreams* to which it explicitly refers. Whereas, in the passage from the dream book, Freud insists upon the acute feeling of *recognition* provoked by the landscape dream image that seemingly reproduces an image from a former life (in the body of the mother) and returns one to it, in the corresponding passage from 'The Uncanny' essay, he focuses instead on the feeling of *strangeness* produced by the image of the female genitals in neurotic men. He goes on to explain that the feeling of strangeness is actually the negative trace of the primal image of the absolutely familiar: the primal 'home' that is the body of the mother. That primal image, however, can *only* be rendered visible when it is reproduced in negative form: as a 'negative' image of the female genitals, displaced into a dream landscape, or even as the very image of 'negation' itself. Here we might recall, in passing, that Freud's famous text called 'Negation' begins with the following telling example of 'negation': ' "you ask who this person in the dream can have been. It was *not* my mother." We emend this: so it *was* his mother.'[9]

It bears mentioning that this unique and fantasmatic image of the maternal body is neither 'natural' nor 'present'. Although it ostensibly provides an *absolutely unique certainty* regarding the place of origin (as Freud puts it, 'there is indeed no other place about which one can assert with such conviction that one has been there once before'), the epistemological status of this claim to 'certainty' is itself uncanny and paradoxically uncertain as it cannot be substantiated by either subjective memory or empirical evidence. The 'unique certainty' of having passed through the mother's body is therefore spectral in nature and the uniquely 'real' image that this passage produces in its wake is therefore *uniquely* unreal as well. Its fantasmatic unreality is in uncanny proximity to its unique claim on reality. The unique image of the place of origin can only be rendered visible through its fantasmatic mechanical counterpart: the birth place makes itself 'known' and leaves its mark through the reproduction of a peculiar image of 'no place' or: 'utopia'.

And it is this uncanny conception of utopia—as a fantasmatic unreal image of a place that is paradoxically impregnated with the

trace of a 'real' (albeit irrecoverable) primal past — that returns us, once again, to Barthes's 'fantasmatic image' and the 'utopian time' in Baudelaire's poetry with which he associates it. The notion of 'utopian time', as Barthes derives it here from Baudelaire and Freud, need not be understood as an escape from history, but rather as an alternative approach to it. Through his inscription of 'utopian time', Barthes asks us to imagine a form of photographic historical writing that would be roughly analogous to Proust's 'involuntary memory', endowed as it is with the power to conjure up unconscious and forgotten traces of past lived experiences as well as unrealized latent potentials. Unlike the memory trace that constitutes the trigger for Proust's 'involuntary memory', however, Barthes's fantasmatic photographic dream-poem image of 'utopian time' conjures up a past prior to any subjective existence and, in so doing, calls forth a thinking of a writing of historical time that reaches back into a past even more remote, and more profoundly 'unconscious', than that described by Proust. But like the action of involuntary memory described by Proust, the critical power at work in 'involuntary remembering' does not lie in the capability to document known past events, but rather in its capacity to create new temporalities that unfold from dormant histories that are embedded in its inscriptions. 'Utopian time', therefore, is a writing of history that unfolds as an unfurling of latently inscribed future potentialities. For this reason, 'utopian time' is expressed in both past and conditional tenses: it is neither purely past nor strictly speaking 'future'. Barthes explicitly calls attention to the photographic qualities of this doubled time by referring to it as 'a second sight which seems to bear me forward to a utopian time, or to carry me back to somewhere in myself: a double movement...' He also inscribes the doubled temporality of this 'second sight' in his caption to the 'Alhambra' photograph, where he re-writes Baudelaire's famous avowal of recognition of an impossible past '*C'est là que j'ai vécu!*' ['It is there that I lived!'] into an affirmation that links that immemorial past to a potential future created by desire: '*C'est là que je voudrais vivre!*' ['It is there that I would want to live!]'

The temporality of history as opened up by 'utopian time' is neither linear nor purely located in the world of consciously lived experiences. However, even if this 'fantasmatic image' — which is both a product of and produced by 'utopian time' — does not conform to reality as it can

be consciously known, it nonetheless cannot be conceived of as purely imaginary or subjective. Its creative potentials are 'real' in the sense that they 'realize' or bring into being latent possibilities in the form of new configurations. Like dreams, these 'utopic' configurations must be read — or interpreted — to disclose their relationship to an unknown (and perhaps even unknowable) past and their potential impact on the thinking of what is or is not possible. The utopian time conjured up by the 'Alhambra' photograph, which is, in some sense, derived from the photographic potentiality of the maternal body (even as it cannot be construed as a 'photograph' of the mother in any simple sense) opens up a new way of approaching the question of the writing of history through the lens of this impossible possibility.

For most readers of *Camera Lucida*, when one invokes the figure of an impossible but 'utopically real' photograph of the mother, it is most common to think immediately of the famous 'Winter Garden Photograph'. The image that goes by this name refers to an un-reproduced photograph that Barthes describes of his mother as a five-year-old girl, with her seven-year-old brother, under the palms of the 'winter garden' in the house in which she was born. After the death of his mother, Barthes searches unsuccessfully for an image of her in which he might be able to recognize the person he had known and loved. In this image, the 'Winter Garden Photograph', that is, in an image of his mother as he never could have 'known' her in any literal sense, he ultimately re-finds her and recognizes her absolutely. As the unique quality of this impossibly 'utopic' recognition is uniquely singular to him and to him alone, he refuses to reproduce this image as a photograph in the book. In his essay, 'The Deaths of Roland Barthes', Jacques Derrida calls attention to the motif of 'utopia' in *Camera Lucida* as it emerges in Barthes's invocation of the 'Winter Garden Photograph'. Glossing Barthes's commentary about the 'truth' of this impossible image, Derrida writes:

> The impossible, sometimes, by chance, becomes possible: as a utopia. This is in fact what he said before his death, though for him, of the Winter Garden Photograph. Beyond analogies, 'it achieved for me, utopically, *the impossible science of the unique being*' [*Camera Lucida*, 71]. He said this uniquely, turned toward his mother and not the

> Mother. But the poignant singularity does not contradict
> the generality, it does not forbid it from having the force of
> law, but only arrows, marks, and signs it. Singular plural.
> Is there, then, already in the first language, the first mark,
> another possibility, another chance except the pain of this
> plural? And what about metonymy? And homonymy? Can
> we suffer from anything else? But could we speak without
> them? ('DRB', 276)

As he picks up on Barthes's insistence upon the 'utopically' 'unique'
and 'singular' quality of the Winter Garden Photograph, Derrida
points to the latent structure of repetition, and hence plurality, that
underwrites and paradoxically renders possible the poignant singularity
of the image that Barthes so cherishes. For Derrida, the very singularity
of this chance event in which an impossibility (the true image of
a unique being is encountered after her death) utopically 'becomes
possible', and can only become 'possible', as it were, because of the
doubled temporality and essentially written status of this utopic scene
of recognition. In other words, to say that 'the impossible, sometimes,
by chance, becomes possible: as a utopia' implies that the photographic
image in question is a form of writing and that as writing it has
the latent potential to inscribe 'utopian time'. But it is only when
photography relinquishes its dominant referential powers and loosens
its grasp on documentation, information, cognition, and consciousness
and returns to its 'first language' as 'mark' or as writing that it opens
itself up 'utopically' to its impossible possibilities. As he continues
his discussion of the Winter Garden Photograph, Derrida repeatedly
emphasizes the term 'utopically' and its relation to writing and to
death:

> What we might playfully call the *mathesis singularis*, what is
> achieved for him 'utopically' in front of the Winter Garden
> Photograph, is impossible and yet takes place, utopically,
> metonymically, as soon as it marks, even 'before' language.
> Barthes speaks of utopia at least twice in *Camera Lucida*.
> Both times between his mother's death and his own — that
> is, inasmuch as he entrusts it to writing: 'Once she was
> dead I no longer had any reason to attune myself to the

progress of the superior Life Force (the race, the species). My particularity could never again universalize itself (unless) utopically, by writing, whose project henceforth would become the unique goal of my life' [*Camera Lucida*, 72]. ('DRB', 276)

Although Derrida alludes (somewhat cryptically here) to a mark 'before' language and with the mention of that mark implicitly conjures up the figure of birth and the maternal body, his focus here is the marked space of writing that Barthes himself explicitly opens up between two deaths: his mother's past death and his own future death.[10] Indeed, as Barthes himself famously and wryly observes in *Camera Lucida*, the book itself is conceived as a form of 'waiting' between those two deaths: 'The only "thought" I can have is that at the end of this first death, my own death is inscribed; between the two, nothing more than waiting...' (*CL*, 93). In the passage by Derrida cited above, he (Derrida) associates 'utopia' with this time of writing that has given up on life's 'possibilities' and hence given itself over to a temporality marked by death. And indeed, much of Derrida's essay on Barthes is devoted to the relation between writing, death, and mourning. And this is certainly not surprising given that Barthes's book is most explicitly a book of mourning and death is everywhere in it.[11]

Neither Derrida nor Barthes overtly acknowledges the striking inverse connection between the 'utopian time' of a past *before birth* conjured up by the Alhambra photograph and the utopic encounter *after death* occasioned by the discovery of the Winter Garden Photograph. This is somewhat surprising given Derrida's explicit interest in the motif of 'utopia' and its relationship to what one might call, following his text, the 'singular plural' of and at the origin. In any case, as should be clear by now, these two 'impossible' photo-images of the 'mother' are uncanny doubles of one another. Furthermore, temporally, they are in a photographically 'negative' relation to one another. As we have already seen, the 'utopic' impossible possibility of the Alhambra photograph recalls the trace of the Mother (and it is important to note that Barthes capitalizes the word 'Mother' here) prior to any subjective or personal incarnation, and thus prior to any simple inscription into human, historical time. In the Winter Garden Photograph, by contrast, the 'utopic' impossible possibility

turns around the fact that the image that Barthes discovers of his mother is an absolutely unique, singular, and particular being, and in that absolute singularity (be it plural or not) the image cannot be rendered legible within the constraints of human, historical time. Neither image is 'visible'; both images rely upon radically unconscious processes of reading and writing. Read in this light, the Winter Garden Photograph, for all its uniqueness, is not merely an impossibly 'utopic' scene of 'recognition' — it is more like an uncanny scene of '*déjà vu*'. And '*déjà vu*', as I have been trying to develop it here, does not refer to the repetition of something that one has seen before, but rather refers to the photographic recurrence of that which was *never* seen before. As such, '*déjà vu*', understood in this sense, returns us to the question of how the photographic maternal bears witness to an un-photographable event. Derrida himself invokes something like this conception of '*déjà vu*' as impossible witness to an unknowable event when, in *Athens, Still Remains*, he writes that the image-sentence-phrase 'we owe ourselves to death' ['*nous nous devons à la mort*'] comes to him, photographically, 'like an original — or a negative without origin'.

This conception of '*déjà vu*' as a photographic witness to an unconscious trace of an unknowable event returns us to the question of history and the place of the mother within that question. While a certain classical philosophical tradition would place the maternal function on the side of 'nature', biology and 'pre-history', in the preceding pages I have been trying to suggest that the figure of the 'photographic maternal' challenges the very temporal field through which one establishes a clear distinction between 'nature' and 'history', between 'pre-historical' and 'historical' events, or between conscious documentation and unconscious latent possibilities.[12] It bears mentioning at this point that, on one level, this derivation of the 'photographic maternal' from Barthes's text might seem somewhat perverse, if not downright nonsensical, given that, throughout *Camera Lucida*, Barthes insists emphatically upon the hyper-referential character of photography (via the famous pivotal assertions that 'the referent adheres' to the photograph and that the *noeme* — or essential truth — of photography can be expressed as: 'it-was-there' ['*ça-a-été*']) and resolutely aims to preserve and protect the image of his own beloved mother from the deadening socializing properties of photographic documentation.

Certainly, this attention to the excessively referential power of photography is, without a doubt, one of the most important tenets of Barthes's book. Indeed, when writing about photographic 'certainty', he asserts that the excessive force of photography's power to 'ratify' past presence overwhelms and cancels out the more fragile power of memory and, for this reason, he suggests that photography and writing are, to some degree, mutually exclusive:

> The Photograph does not necessarily say *what is no longer*, but only and for certain *what has been*. This distinction is decisive. In front of a photograph, our consciousness does not necessarily take the nostalgic path of memory (how many photographs are outside of individual time). But for every photograph existing in the world, the path of certainty: the Photograph's essence is to ratify what it represents... No writing can give me this certainty. It is the misfortune (but also perhaps the voluptuous pleasure) of language not to be able to authenticate itself. The *noeme* of language is perhaps this impotence... (*CL*, 85–87)

Barthes suggests that the uncanny power of photographic certainty lies in the fact that it is not merely 'conscious', but super-conscious — more conscious than consciousness itself: consciousness devoid of and indifferent to memory, subjectivity, and, I would suggest, even history. The paradox that Barthes points to throughout *Camera Lucida* is that precisely *because* photography is endowed with an excessive power to document the 'reality' of past-ness itself, it is incapable of language, of speech, of memory, of writing and of history. Recalling, once again, Proust's distinction between voluntary and involuntary memory, we might say that Barthes implies that photography's capacity for this over-voluntary memory renders it incapable of telling a story, or creating a permeable associative field in which events can be ordered and reordered in relation to one another. Barthes himself says explicitly that the photograph 'does not invent' (*CL*, 87) and that it 'possesses an evidential force, and that its testimony bears not on the object but on time' (*CL*, 89). For Barthes, this capacity for super-certainty predetermines photography's propensity to be used as an extension of the police insofar as its 'default' rhetorical position is that of 'proof' or

'evidence'. In an attempt to convey the alienating anxiety produced by this evidentiary power, he recounts the following anecdote:

> One day I received from a photographer a picture of myself which I could not remember being taken, for all my efforts; I inspected the tie, the sweater to discover in what circumstances I had worn them; to no avail. And yet, *because it was a photograph* I could not deny that I had been *there* (even if I did not know *where*). This distortion between certainty and oblivion gave me a kind of vertigo, something of a 'detective' anguish (the theme of *Blow-Up* was not far off); I went to the photographer's show as to a police investigation, to learn at last what I no longer knew about myself. (*CL*, 85)

Curiously, this description of an uncanny and disturbing convergence between 'certainty' and 'oblivion' regarding the undeniable status of a place ('*there*') where I 'know' that I have been before, but that I cannot remember, recalls and negates the scene of familiar recognition of the primal home in the maternal body that was conjured up by the Alhambra photograph. In both cases, there is a sense of 'certainty' of 'having been there before' that cannot be corroborated by any subjective act of memory. In the case cited above, however, there is only one possible resolution to the crime drama in which Barthes finds himself: in one way or another, he must produce a conscious correspondence between himself and the image of himself with which he is confronted. The relationship between those two images will be relegated to 'consciousness' even if he ultimately remains unable to recall his prior presence at the scene of the photographic event in question. Photography's power thereby subjects him to its implacable objectification, to which he must give himself over willingly. But in the case of the Alhambra photograph, 'certainty' is detached from any referential or evidentiary 'photographic' power; it creates a temporal field whose claim on reality is entirely dependent on the fragile and mobile fate of its unconscious traces of '*déjà vu*' that are brought to light by singular acts of reading and writing.

These two scenes, however, are related to one another. By reading them through one another, an important (but somewhat

latent) aspect of Barthes's book becomes somewhat more legible. From what we have seen, Barthes inscribes (at least) two different kinds of photographic principles in his book: the first is super-conscious, referential, visible, and 'powerful'. This photographic principle fixes events in time by freezing time into the living death of a preserved past. Following the analogy with Proust, we might call this 'voluntary photography'. However, alongside this principle, there is also another photographic principle: it is a non-referential, rebus-like, and profoundly 'unconscious'. It mobilizes temporality but, like the form of writing that it is, its claim on factual authenticity remains, as Barthes describes the *noeme* of language: 'impotent'. This photographic principle does not, in fact, represent; instead, it activates the temporality of '*dejá vu*' and, at the risk of being too schematic, we might call it 'involuntary photography'.

It is important to clarify at this juncture that this 'Proustian' inflected reading of these two photographic principles in Barthes's book might appear to go 'against the grain' (and even actively contradict) his own explicit statements about the photograph's non-relationship to Proustian time. He says, explicitly, for example: 'The Photograph does not call up the past (nothing Proustian in a photograph). The effect it produces upon me is not to restore what has been abolished (by time, by distance) but to attest that what I see has indeed existed' (*CL*, 82). Or this: 'In the Photograph, Time's immobilization assumes only an excessive, monstrous, mode: Time is engorged...Not only is the Photograph never, in essence, a memory (whose grammatical expression would be the perfect tense, whereas the tense of the Photograph is the aorist), but it actually blocks memory, quickly becomes a counter-memory' (*CL*, 91). It is important to note that in all of these emphatic (and non-negotiable) assertions, Barthes is referring to the specifically visible, tangible object that he calls 'The Photograph'. And indeed, everything that he says regarding this thing he calls 'The Photograph' — (be it as phenomenological experience or ontological entity) — remains determined by his attempt to account for the various forms of 'power' inherent in the non-verbal, excessively referential force of what I have been calling 'voluntary photography'. Furthermore, at the end of the book, Barthes follows the path of this excessive referential power to the point of arriving at its limit, which he calls 'madness'.

> Here is where the madness is, for until this day no
> representation could assure me of the past of a thing except
> by intermediaries; but with the Photograph, my certainty
> is immediate: no one in the world can undeceive me. The
> Photograph then becomes a bizarre *medium*, a new form of
> hallucination, so to speak, a modest, shared hallucination
> (on the one hand, 'it is not there', on the other 'but it has
> indeed been'): a mad image, chafed by reality. (*CL*, 115)

At the end of the book, Barthes argues that the excessive certainty of
'The Photograph' destines it to become received as either 'mad' or
'tame'. When 'mad', 'The Photograph' becomes tactile: it allows the
dead to touch and be touched and the name that Barthes gives for this
impossible loving embrace is 'Pity': 'In the love stirred by Photography
(by certain photographs), another music is heard, its name, old-
fashioned: Pity' (*CL*, 116). When tame, 'The Photograph' becomes
omnipotent and 'crushes all other images by its tyranny' (*CL*, 118). In
both cases, however, either as 'mad' or as 'tame', 'The Photograph' uses
it power of certainty to disable the latent potentialities of language: it
neither reads nor writes.

 Nonetheless, despite Barthes's numerous claims regarding the
excessive referential certainty of 'The Photograph', there is, as we have
already seen in our reading of the 'Alhambra' photograph, another
story (and another history) regarding photographic writing inscribed
within his book. Certainly, in his own text, photography and writing
are not simply opposed to one another. *Camera Lucida* is not simply a
book 'about' photography; it is itself a book of 'photographic' writing.
And this is so on many levels beginning with the fact that, from its
very first sentences onward, Barthes conjures up various kinds of word-
images that are 'photographic' even if they do appear in the form
of actual photographs. Among the most striking examples, we find
the following pictorial 'explanation' of the relationship between the
Photograph and the referent:

> It is as if the Photograph always carries its referent with itself,
> both affected by the same amorous or funeral immobility, at
> the very heart of the moving world; they are glued together,
> limb by limb, like the condemned man and the corpse in

certain tortures; or even like those pairs of fish (sharks, I think, according to Michelet) which navigate in convoy, as though united in eternal coitus. (*CL*, 5–6)

Furthermore, there are many (ostensibly real, but who knows?) photographs in the book that Barthes chooses to reproduce verbally rather than photographically. In one of the most famous (and arguably self-consciously 'Proustian') passages in the book, Barthes presents a theory of 'History' as a temporal field constituted by his (implicitly partly unconscious) relationship to the time that his mother was alive before him — that is, to the time *before* his own conception and birth.[13] He punctuates this theory with a description of a scene in which he contemplates a photograph of himself as a child, in his mother's arms; by looking at the photograph, he becomes able to awaken the long dormant (and presumably otherwise irretrievable) memory traces of the feel of the texture of her dress and the smell of her powder:

> Thus the life of someone whose existence has somewhat preceded our own encloses in its particularity the very tension of History, its division. History is hysterical: it is constituted only if we consider it, only if we look at it — and in order to look at it, we must be excluded from it. As a living soul, I am the very contrary of History, I am what belies it, destroys it for the sake of my own history (impossible for me to believe in 'witnesses'; impossible, at least to be one; Michelet was able to write virtually nothing about his own time). That is what the time when my mother was alive *before me* is — History (moreover, it is the period which interests me most, historically). No anamnesis could ever make me glimpse this time starting from myself (this is the definition of anamnesis) — whereas, contemplating a photograph in which she is hugging me, a child, against her, I can waken in myself the rumpled softness of her crêpe de Chine and the perfume of her rice powder. (*CL*, 65)

These sensory memories, resurrected by the photographic scene, do indeed enlarge the field of his memory beyond the scope of his

subjective, conscious memory. Here the photograph appears (in some sense) to 'bear witness' to something that would have otherwise remained temporally inaccessible: the time *before* him in his mother's life. In other words, this photograph (utopically and impossibly) opens up and extends the field of anamnesis from the time that 'starts from me' to the time *before* me. In this scene, something is transmitted, through the latent inscriptions of what Benjamin might call an entire 'image world' that is embedded in 'her crêpe de Chine' and the perfume of her rice powder. Furthermore, for this 'awakening' to occur, it would appear that the narrator must, in some sense, allow himself to reproduce the photograph in his own psyche. Only by responding 'photographically', as it were, to this image — that is, by giving himself over to the unconscious photographic capacities within his own psyche, can these latent inscriptions of the lost life (and perhaps the life is neither strictly his nor hers) be awakened. It is no accident that Barthes conjures up this scene of 'involuntary photography' in the context of a discussion of the limits of the possibility of writing 'History' and writing historically. In this context, it is also important to recall — and perhaps to take seriously — that the question of 'History' — specifically the question of how to write history after the advent of photography — is, arguably, the central conceptual concern of *Camera Lucida*. (For this reason, perhaps, Michelet appears like something of a nineteenth-century proxy for Barthes throughout the book.) Many — if not most — of the most important critical images (reproduced as photographs or not) in the book *come from* or *point to* obscure aspects of nineteenth-century desires, events, and traumas. It is easy to lose sight of the importance of Barthes's reflections on history in *Camera Lucida* as this question is easily over-shadowed by his inimitable narrative of mourning the mother through writing about photography. Throughout this essay, however, I have been trying to suggest that photography and the mother are not accidentally related and that the specific links between photography and the maternal function are themselves central to Barthes's reflections on writing history. Furthermore, as we have seen through our reading of the 'Alhambra image', Barthes's most compelling insights about the possibilities and limits of writing history may not be immediately visible. They are inscribed, from the beginning, latently, within the photographic scene of his own writing.

Let us recall that the opening lines of *Camera Lucida* recount the narration of a very striking photographic scene:

> One day, quite some time ago, I happened on a photograph of Napoleon's youngest brother, Jerome, taken in 1852. And I realized then, with an amazement I have not been able to lessen since: 'I am looking at eyes that looked at the Emperor'. Sometimes I would mention this amazement, but since no one seemed to share it, nor even to understand it (life consists of these little touches of solitude), I forgot about it. My interest in photography took a more cultural turn. (*CL*, 3)

Although this opening image has received relatively little critical attention,[14] it establishes, from the beginning, the complexity of the reflections on history that also bind writing to photography and the mother throughout the remainder of the book. It is a vertiginously un-canny scene of '*déjà vu*'. The first person narrator verbally reproduces an ostensibly forgotten memory of an earlier image of himself looking at a photograph (taken during the *Second Empire*, in 1852, under the rule of Napoleon III) that bears witness to a witness (Napoleon's youngest brother Jérôme) to the Emperor himself and through him to the last historical political period that predated any possible photographic historical documentation.[15] This moment, which opens the book and then is explicitly 'forgotten' by its narrator, who fails to engage the attention of his entourage, inaugurates attentiveness to the latent, but un-told, legacies of the nineteenth century. Here, as in the passage we just read, in which Barthes reads the image of himself with his mother, the narrator both writes about photography and writes photographically. This 'photographic writing' cannot show anything directly; it animates a potential field of associations through which the time 'before' is awakened otherwise and, when read, brings the 'déjà vu' of a possible, impossible future to life.

II. Photo-readings in Hélène Cixous: The Will to Photography and Dark-Room Writing
In the preceding pages, we have begun to explore how photography might be linked, from the beginning, as it were, to the body of the

mother and to the maternal function as it operates within the psyche. When looked at in this light, 'photography' becomes something other than its capacity to document or record something known or knowable. Indeed, as we have seen through our reading of the various 'unrepresented' (or utopic) photographs in Barthes's text, a certain 'truth' of photography operates at the very limits of what can be imagined as 'visible' or even 'possible'. When photography loosens its grasp on its various referential conscious powers (to know, to prove, to document) and gives itself over to be read as a form of writing, it calls for a mode of reading (of events, texts, and the world) that is neither conscious nor unconscious as conventionally understood. And, as we have begun to see through our reading of these photo-text-images in Barthes's text, this mode of photographic reading is intimately connected with the figure of the mother both *in* photographic writing and *as* photographic writing. I would argue (although such a claim is difficult to substantiate here for all kinds of reasons) that this link between photography and the maternal function shows up with remarkable consistency in various kinds of texts including writings by Proust, theoretical texts by Freud, and even the film *Blade Runner*.[16]

For the purposes of this discussion, however, I would like to turn briefly to the relationship between photography and the maternal function in some of Hélène Cixous's recent writings. Over the last two decades or so, a period during which her works have become more explicitly marked by her ongoing readings of Proust, Hélène Cixous has increasingly (and perhaps not coincidentally) inscribed reflections on the negative powers of photography and the impossible possibilities of photographic writing into her works. In the shelter of her solitary chamber, Cixous develops her readings of Proust and puts them to work otherwise in her own writing. The traces of these Proustian photo-readings are inscribed just about everywhere in the recent texts, but they become particularly visible in the scenes that turn around the mother, the grandmother, and the photographic maternal function.

The Will to Photography in So Close
To be sure, however, from a certain point of view, photography is Hélène Cixous's declared enemy.[17] This is, indeed, what she says explicitly in the inaugural scene of her recent novel, *So Close* [Si Près], where she writes:

'Photography I've always thought is the enemy, my enemy exactly, the adversary, one can't take photos and write, I say to myself.' (*SC*, 3)[18]

As we shall see, Cixous specifies that photography is the 'adversary' and 'exactly' her enemy because it remains at once too far and too close to writing. It is no accident, however, that photography, in all its capacities, conscious and otherwise, casts such a large shadow over the writing in and of this particular book. In this novel, Cixous tells the story of her ambivalent return to Algeria, her birth place, and the place to which she vowed for decades that she would never return. The narrator's powerful ambivalence about the possibility or the impossibility of her return to Algeria is reflected, in part, through her powerful expressions of negativity regarding the ambiguous powers of photography. Throughout *So Close*, the narrator punctuates the story of this impossible-possible return to the place of her birth with ongoing reflections on what it means for her to take (or not to take) a photograph of her mother, in a bathing suit, on her ninety-fifth birthday.

From its opening scene onward, in which the narrator catches herself in the act of taking a 'mental photograph' of her mother on her birthday, the novel presents the photographic act as actively and violently opposed to the life given by writing: that is, it is both writing's negative image and the very negation of its mode of being. As the inaugural scene unfolds, the narrator carries on a continuous, reflective diatribe against photography. Within this long speech detailing why photography is the negation of writing, she even goes so far as to negate her own negative argument by recounting how her friend says 'exactly the opposite, there is writing in photography, he says'. Nonetheless, despite his objections, she continues her rant as follows:

> ... in the idea of taking a photograph technically everything frightens me, the idea of 'taking' whereas in my opinion the camera cuts, out of a photograph, the infinite flux of the untakeable, whereas writing takes nothing at all, writing dreams of not stopping what is in the process of being lost, nothing more powerless and desperate, thus nothing more faithful to the infidelities of life I say to myself... (*SC*, 3)

Photography, she tells herself, takes too much. Its capacity to 'take' is overwhelmingly powerful — excessively powerful — as it seizes hold of everything including even the 'untakeable' itself: the very part of 'life' that is truly vital and hence 'untakeable' precisely and paradoxically because it is all too 'takeable'. It imposes its powerful will on life by stripping it of all its movement and precious precariousness. Its power is nefarious: it competes with death by anticipating it, and thus precipitously makes it come too soon. Its precociousness is brutal. Throughout *So Close*, the narrator tries to defend herself against this negative power of photography by countering it point by point with precise negations and denials. At every turn, she disavows any and all relation to photography. On numerous occasions, as if in response to an unspoken query, she repeatedly asserts that she 'never took a photo'. At other moments, she insists that she has no movie camera either and continues to protest (as if countering an opposing force) that she has *never* taken a photo, *not ever*. Well into the body of the book, the narrator says:

> I have no movie camera. I have never had a movie camera in my whole life I have never taken a photo, I have never taken anything, I have pushed the 'you shall make for yourself no graven image' to the height of extremes, I have never taken a photo of my beloved, there are no photos of our life, not a single image, I did not take photos of our children, I did not take my brother, or my women friends, or my friend J.D. I never fought off a desire to photograph or to film, I never had the sudden urge to keep a visual trace, I should have perhaps sometimes I will never know if I did the wrong thing I can't I can no longer look back it's too late. (*SC*, 70)

But at the very moment when she affirms that 'it is too late' even to regret *not* having taken all the photos that she never took, it is already 'too late' once *again* because she herself has already been taken by an unexpected and unpredictable desire to film her mother. And it's done. The decision is made in a photographic flash, instantaneously. Nevertheless, throughout the negative speech she makes against photography, and despite its manifest content, she finds herself looking for her friend Ruth Beckermann's movie camera

(which she had left in her office), and hence the film of her mother that she had never wanted to make is already underway, despite her conscious intentions to the contrary:

> I have never touched a movie camera. I have never put an apparatus for looking between desired subjects and the retinas of my soul. Without explanation, I came running back down. My mother was already in her film. In the film in which she is the subject, the cause. (*SC*, 70)

> *Je n'ai jamais touché une caméra. Je n'ai jamais mis un appareil à regarder entre des sujets désirés et les rétines de mon âme. Sans explication. Je suis redescendue en courant. Ma mère était déjà dans son film. Dans le film dont elle est le sujet, la cause.* (*SP*, 99)

If we look at the excessively negative declarations in *So Close* more closely, it appears clear (and one doesn't need to avail oneself of what, in French, is the astute gaze known as '*l'oeil américain*', 'the American eye', to see it): these denials regarding photography are not simple affirmations of negative feelings; they are psychic disavowals — and, as such, they bear the trace of unavowed or unavowable desires that can *only* be expressed in the negative. In other words, the negative declaration *against* photography is itself photographic in form; its negative inscription precedes and makes possible the development of a latent future image. We will return to this point later on.

But if, for the time being, one looks at this passage even more closely, this time by moving from the meaning of the words to the sounds of the words as they are written in French, we can hear, at the level of their repeated and insistent sounds, an auditory image that corresponds in another way to this photographic signifying effect. The narrator incessantly repeats the French phrase '*je n'ai, jamais*' ('I have, never'). In the repetition of the auditory syllables: '*je n'ai*' (negation of the verb '*avoir*', to have) one can hear the distant echo of an affirmation of birth ('*je nais*', 'I am born'). There is only a little negative, a little step [*pas*], between *naître* and *ne pas être*; between birth and the negation of life. Now, *So Close* plays constantly on the potential confusion between the various forms of the verb *naître* [to be born] and all the negative

possibilities of the verb *être* [*not* 'to be']. Here, for example, is how the phonemes intersect in the following passage:

> I had just written 'I was born in Algeria' and once again I felt that I didn't know what I was saying, what this sentence was saying to me, I don't know what it was thinking by saying 'in Algeria' or borninAlgeria or what I thought of being born in without being of, being of nothingness, not being of Algeria, but with Algeria nonetheless. I felt this uncanny and exhilarating strangeness that has the gift of repeating itself, reigniting itself with each interrogation. (*SC*, 45)

> *Je venais d'écrire 'je suis née en Algérie' et une fois encore je sentis que je ne savais pas ce que je disais, ce que me disait cette phrase, je ne sais pas ce qu'elle pensait en disant 'en Algérie' ou néeanlagérie ni ce que je pensais d'être née sans en être, d'être du néant, de ne pas être d'Algérie, mais avec Algérie néanmoins. J'éprouvai cette inquiétante et enivrante étrangeté qui a ce don de se répéter, se rallumer, à chaque interrogatoire.* (*SP*, 66)

One could even say that the question *'naître ou ne pas être'* ['to be born or not to be'] in Algeria is one of the obsessive preoccupations of *So Close*. This question haunts the book at several levels. At one moment, for example, the narrator asks the friend she calls by the name 'Telephone': 'If I say to you *Né* [born], I say to the Telephone, what is it?' (*SC*, 48) And then, a little later, she asks her mother, 'How do you write "*Né*", I say to my mother. *Née* Klein, says my mother. — The other one, I say. When you say "*Né*" on the telephone when you talk to your sister' (*SC*, 48). Refusing to recognize the narrator's insistence on the negative possibilities inscribed within the birth word, '*Né*', her mother replies: 'It is not written at all. It is also not said' (*SC*, 48). But after the daughter's repeated objections, the mother clarifies the matter as follows: 'One says it but you can't write it. Perhaps it's said in our district of Osnabrück. But as for me, I say *Nein*. No, I don't say *Né*' (*SC*, 48). In these two examples, there is an ambiguous tension (which makes itself heard specifically when the place of birth is mentioned) between the affirmation of birth on the one hand and the expression of a negative linguistic power on the other. The narrator cannot say

'I was born in Algeria' ['*je suis née en Algérie*'] without by the same token denying this birth in Algeria, while the mother explains that in spite of the fact that one *can* say '*Né*' to mean 'no' in her native city, Osnabrück, she herself does not say '*Ne*' but '*Nein*'. Whereas the mother affirms her negation clearly, the daughter denies the possibility of declaring her birthplace.

On this commentary about telephonic exchanges, let us recall that at the beginning of the book the narrator affirms that her love for the telephone is precisely the counterpart of her aversion for photography:

> Here is an odd thing: my love for the Telephone is equal in intensity to my antipathy for the camera. That's because the Telephone is you. The camera is a prosthesis, it's a pair of optical pliers, an ocular harpoon, an avid prolongation of me. (*SC*, 5)

Although the author here declares her opinion that the telephone respects the alterity of the other, whereas photography is merely a narcissistic and mortiferous weapon of the self, it is not so clear that her book entirely accords with this judgment. The telephone, defined against photography, presented as its positive negative, as it were, is itself implied in the photographic structure of the book and subject to its obscure law. And, apparently against the will of the author, the writing of the book is marked by photographic effects.

Now the traces of the obscure, duplicitous and contradictory law of photography are at work from the very first pages of *So Close*, and perhaps even before. Although the book begins with the announcement of a verbal 'blow', involuntarily inflicted by the narrator on her mother on the anniversary of her birth, we discover immediately that this verbal blow is in fact merely the after-effect of a primordial image that appears for the first time before the beginning of the book, and on the basis of which the narrative gets going. The image in question reappears in the text in the form of a detailed description of a mental photograph of the mother, in a bathing suit, taken by the daughter on the former's ninety-fifth birthday. The text has us see the photo of the mother as it develops progressively in the eyes of the daughter, who watches herself watching her mother in the bathing suit and finds herself caught up in her avid desire to take a picture of her. She says:

My gaze was busy mentally photographing the desired face, the face of her birthday, I wanted to imprint in I know not what immortal wax my dearly beloved's features when she turned ninety-five years old... I was given over entirely to this secret attempt to steal a picture taken from my mother in a bathing suit [*ma mère en maillot*], I was hoping that she was totally unaware of it, I was hoping to absorb her figure, the muscular drive of prey that makes its nest in me was brooding over this face in transformation... (*SC*, 2)

Maman changes so quickly, I say to myself, this mobility is like that of a five-year old child, I realize that this predatory passion keeps me captive myself, I want to take and I am taken by the need to take, it's a frenzy that devastates me, it's exhausting to want to hold on to what is passing, I am haunted by a mental camera, I who have never taken a photo in my life. Photography I've always thought is the enemy, my enemy exactly, the adversary, one can't takes photos and write, I say to myself. (*SC*, 2–3)

But if the narrator is caught up in this drive that condemns her to want what she has never wanted, namely to take a photo of her mother, this is because photography claims to be able to deny nothingness by offering a desired image in the place of the unimaginable. So if she lets herself be taken by photography at the beginning of the book, this is the sign that she is already haunted by the anticipation of an intolerable image. In other words, the very event of the unexpected appearance of the mother in a bathing suit on which the book opens is always already marked by the negative of that image, the image of her future disappearance.

As we have already seen, according to the narrator photography is the enemy of writing, since it is too powerful, too grasping, too conscious. She reproaches it in particular with its authoritarian and excessive *will*. By declaring herself untouched by any photographic desire, she is trying to protect herself against the grip of that will. But, paradoxically, it is in seeing herself become involuntarily transformed into a psychic camera that she discovers, unbeknownst to herself and against her will, that there is another aspect of photography, something that can here be called provisionally (recognizing the strong presence

of Proust who haunts every line of the text and following our reading of Barthes) *involuntary photography*.

The uncanny power of involuntary photography is inscribed throughout *So Close*, but is declared clearly in the scene where the mother is filmed in a two-piece bathing suit. This scene, which follows the long passage of denials about photography quoted above ('I have no movie camera. I have never had a movie camera in my whole life I have never taken a photo . . .') reproduces, but differently, the first image of the mother. This time, after having defended herself verbally against photography, the daughter gives in to the sudden desire to film her mother with the camera she never wanted to have. And, seeing herself obey the obscure will of involuntary photography, she suddenly sees her mother, for the first time, otherwise:

> The idea occurs to me that perhaps it's not she who obeys, but I who am obeying a will external to my will which has taken over my will by a trick, it may be that it's my mother's will, hidden to herself or on the contrary hidden by herself, silent, powerful, of unquestionable authority, which dictated to me this abrupt and crazy decision: to film my mother in a purple two-piece. I filmed. But what did I film? My mother's will. I thought: Maman's will and testament. . . . Now: I see my mother. It is: the first time. I see and I see that I see. I see my mother in painting. I see what I have as yet never seen what I will never see. I take the camera and I paint my mother with large brush strokes, I have never seen my mother I say to myself I have never seen her so close. (*SC*, 71)

The film of the mother in her bathing suit [*en maillot*] does not take the mother's life. To the contrary, the act of filming gives birth for the first time, and after the fact, to a primordial vision of a vital and secret life that her daughter could never have seen otherwise. The scene is punctuated by several figures of birth. The word *maillot* after all, refers to the swaddling of the new born. But the film sequence of the mother *en maillot* or *au maillot* also implicitly refers to the birth of the daughter herself. In the sentence that precedes the beginning of the film of the mother, the narrator says, 'The greatest illusion is to think

that what is passed is finished, I say to myself' (*SC*, 70). Here we might note in passing, as though by coincidence, that the greatest film on the first World War (the period of the mother's childhood), namely *La grande illusion*, came out in 1937, the year of Hélène Cixous's birth. The film shot by the daughter gives birth to this mother who is already 'in her film' ['*dans son film*'], and this maternal filming in turn gives birth to the daughter. At the end of this sequence, the filmic act gently transforms itself into a gesture of painting, and the vital image that comes back at this moment of grace gives access to the vision of another reality of life — life lived differently, as one encounters it in art, a dream or literature.

It is not by chance that the mother is at the centre of this photographic vision. Throughout Hélène Cixous's work, the mother is always on the side of photography. She takes photos, she loves them and expresses her loves through them. On this point, let us note this passage from *Osnabrück* in which Cixous, speaking of her mother, writes: 'Eve takes photos. It's through love. She loves flowers in photos. She plants in photos' (*O*, 37).[19] But the link that attaches the mother to photography is still more complex. This link is a knot, an obscure navel of Hélène Cixous's writing. As we have already begun to see, this knot is comprised of a number of principal strands: 1) the history of the maternal line in its relation to the history of cities; 2) the reading of Proust; 3) the photographic conception of the unconscious; 4) the primal scene of writing. In several of Cixous's recent books, these four preoccupations are woven together through the inscription of the dark powers of photography and establish secret relations between them.

Dark Room Writing
Before concluding, I would like to turn very briefly to one more striking example of how 'involuntary photography' comes to assume an important place within Cixous's writing. Photography, it seems, is not simply the 'enemy' of her writing, it also inhabits and haunts her texts as a ghostly, unknowing and unconscious ally of her efforts to tell certain kinds of stories that will always remain, at least to some extent, both untellable and untold. In a novel published in 2001 which to my knowledge has not yet been translated into English, *Benjamin à Montaigne: il ne faut pas le dire* [*Benjamin to Montaigne: It Must Not*

Be Said], Cixous places a photograph of a character, Benjamin, at the dark center of the novel's labyrinthine narrative. Benjamin's repressed and latent story develops 'photographically' against the backdrop of the narrator's mother's narrative of returning, with her sister, to Osnabrück, the birth city in Germany from which she was exiled during the war. Throughout the book, Cixous refers repeatedly to a number of cherished writers including Stendhal, Rimbaud, and Montaigne. But through the conjunction of the motifs of photography, reading, and the figure of the grandmother, she establishes a special connection to Proust's writings on, about, and through photography.[20]

In this context, it might be helpful to recall that one of the most famous depictions of the perverse power of photography in Proust concerns the narrator's grandmother who has herself photographed before her death, hoping thus to be able to lessen the future suffering of her grandson by the consoling image of her face. But the beloved expression of the grandmother's face is spoiled by the grandson during the sitting because he does not understand that she wants to have herself photographed. His belated understanding of the meaning of the photo provokes reflections on the place occupied by the dead in our memories and our hearts. Cixous explicitly invokes Proust in *Benjamin à Montaigne, il ne faut pas le dire*, when she mentions her need for a room of her own for the four occupations necessary for writing: reading, day-dreaming, tears, and pleasure.[21] But she also alludes implicitly to Proust through the thoughts provoked by stories about photos.

Now, we must pay great attention to the word '*histoire*' (which means both 'history' and 'story' in French) in this context. In general in Cixous's work, photos are not endowed with memory, they have no relation to so-called reality; they do not represent history and they are not representatives of history. On the contrary, they are almost always negative histories or negatives of history because they occupy the place of what is deprived of memory or experience and that runs the risk of being lost forever. On this point, one thinks, for example, of the violence of the scene in which the narrator of *Reveries of the Wild Woman: Primal Scenes* takes imaginary photos of her childhood classroom in Algeria in order to 'inexist' (her word) the lying and violent world of 'frenchalgeria':

> Whereupon I took my father's camera, broken beyond
> repair, which my mother had thrown in the trash but which
> I fished out even though beyond repair. And I made it into
> a tool for fabricating ghosts. I forced it on the classroom.
> With the vacant camera I snapped pictures of the teachers.
> Dozens of nonexistent snapshops. So I inexisted them. All.
> One after another. I gazed at them from the point of view
> of the absence of a gaze.[22]

One thinks too of the famous statement of Gregor, the fictive lover
of *Manhattan*, who says 'here take my picture' to prove that he really
exists, whereas the photo constitutes the very proof of the contrary.[23]
In *Benjamin à Montaigne*, however, photos are at the navel of the
story. Set off against the main story of the belated visit of the two
old German-Jewish sisters (Selma and Jennie) to their native city
Osnabrück, one discovers the shadow cast by the story of a photo of the
grandmother. Here, in contrast to Proust, it is not a photo taken *of* the
grandmother, but a photo kept *by* her. The maternal grandmother of
the narrator, Omi, keeps an image of her little brother Benjamin, who
was expelled from the family and exiled in the USA, where he died. The
family no longer speaks about Benjamin; Omi does not speak about
her photo, but she keeps it safe. Omi, the grandmother, retains the
image of Benjamin, the one omitted [*l'omis*] from the family history.
Suddenly, in the middle of the book, the history of this Benjamin who
disappeared bursts violently from the frame of the photograph in which
it had been sleeping silently for years. In a passage in which the narrator
is speaking to her mother and her aunt of their trip to Osnabrück, she
describes the process of photographic awakening as follows:

> Suddenly I needed Benjamin and this story about which one
> never speaks because it is precisely the story about which one
> never speaks which is the key to the stories that one tells.
> Each time long ago that I had asked Omi my grandmother
> who is this Benjamin she had always answered it's my
> little brother while looking at the photo with a love that
> was intimidated regretful and distracted from herself... he
> was put on the boat and immediately after he died in
> Cincinnati, her childhood brother born nine months from

her, the very early dead one whose photo she never let go. In Oran Benjamin reigned alone in the dark dining-room surrounded by frames where there were no longer the large photos of relatives lost between Dresden and Oran. He had survived the moves and the *Seelige Vater und Mutter* had perished. This Benjamin had always been unreadable. He was the photo of the undecipherable, I told myself. (*BM*, 137–138)

And then her mother adds:

I don't know why this idea of Benjamin whom one never spoke about anymore suddenly came up in the train. The greatest error is to think that the story about which nobody speaks for seventy years is a finished and decomposed thing. And the greatest surprise is how a story like that suddenly comes back, as if the joltings of the train had dislodged a dormant kidney stone. (*BM*, 138)

The paradoxical power of the photo of this Benjamin resides in the fact that it has never illuminated anything. On the contrary, it is, as the narrator says, 'the photo of the undecipherable'. Thus, by showing nothing of the history that it secretly preserves, the photo keeps the very old lost history of Benjamin safe from the ravages of the passage of time. The photo of Benjamin is merely a negative trace of that history. But through this negative inscription it safeguards the fragile possibility of its potential future survival. In other words, this photo remains in the primitive state of a prehistory that has never been 'developed' — it never emerged from the darkroom of its birth. Here we might recall that in 'Freud and the Scene of Writing', Jacques Derrida reminds us that Freud uses photographic language to define the structure of the unconscious and to explain resistance and the return of the repressed.[24] For Hélène Cixous, following Proust, Freud, and Derrida, it is within such darkrooms that writing is born. As she writes in a passage from *L'Amour du loup* [*Love of the Wolf*] about the dark room shelters from which writing emerges:

Shelters are not on earth, they are subterranean... places where books incubate. Or else they are elevated caves,

water closets, small rooms that protect the four solitary and delicious occupations to which Proust gives the generic names — reading reverie tears pleasure. These four occupations set writing into motion. But all these rooms are the places of origin of primal *visions*. They are cameras, (*Kamera, Kammer*) cases for making images . . . [25]

Les abris ne sont pas sur terre. Ils sont souterrains . . . lieux où couvent les livres.

Ou bien ce sont des cavernes en étage élevé, des cabinets, de petites pièces qui protègent les quatre occupations solitaires et délicieuses dont Proust donne les noms génériques — la lecture la rêverie les larmes la volupté. Ces quatre occupations sont des embrayeurs d'écriture. Mais toutes ces pièces sont les lieux d'origine des visions primitives. Ce sont des caméras, (Kamera, Kammer) des boîtes à fabriquer des images . . .

This uncanny original dark room is housed in the body of the photographic maternal function. It is there, in the utopic space of that *camera obscura* to which we can only return in the images we make of it in dreams and in writing, that we have the chance to encounter the latent traces of as yet unwritten future histories. Writing photographically, both Barthes and Cixous bear witness to the world as it was never seen before, but as it is brought to life out of the primal images that are fabricated into a special kind of 'historical fiction' in the dark womb of photography.

Notes

[1] Jacques Derrida, 'The Deaths of Roland Barthes', trans. Pascale-Anne Brault and Michael Naas, in *Psyche: Inventions of the Other,* vol. I, eds. Peggy Kamuf and Elizabeth Rottenberg. (Stanford, CA: Stanford University Press, 2007), 264–298. All subsequent references to this text will refer to this edition and will be indicated by 'DRB' followed by the relevant page number.

[2] Jacques Derrida, *Athens, Still Remains: The Photographs of Jean-François Bonhomme,* trans. Pascale-Anne Brault and Michael Naas (New York: Fordham University Press, 2010). All subsequent references to this edition will be indicated by *ASR* followed by the relevant page number.

³ Roland Barthes, *Camera Lucida: Reflections on Photography*, trans. Richard Howard (New York: The Noonday Press, Farrar, Strauss and Giroux, 1981), 38–40. All subsequent references to this edition will be indicated by *CL* followed by the relevant page number. The original French edition is *La Chambre claire: Note sur la photographie* (Paris: Gallimard, Seuil, 1980) 66–68. All future references to this edition will be indicated by *CC* followed by the relevant page number. Among the few critics who have discussed the 'Alhambra' passage and/or its accompanying image in depth are Nancy Shawcross, Timothy Murray, Diana Knight and Gordon Hughes. Curiously, as I will discuss later, Jacques Derrida alludes to the passage, almost invokes it, but does not in fact discuss it directly. See Nancy M. Shawcross, 'Correspondences: Baudelaire and Barthes', in *Roland Barthes on Photography* (Gainesville, FL: University Press of Florida, 1997), 46–66; Timothy Murray, 'Photo-Medusa: Roland Barthes Incorporated', in *Like a Film: Ideological Fantasy on Screen, Camera and Canvas* (London and New York: Routledge, 1993), 65–97; Diana Knight, 'Return Journey: The South-West', in *Barthes and Utopia: Space, Travel, Writing* (Oxford: Clarendon Press, 1997), 219–243; Gordon Hughes, '*Camera Lucida*, Circa 1980', *Reflections on Roland Barthes's* Camera Lucida, ed. Geoffrey Batchen (Cambridge and London: MIT Press, 2009), 193–209.

⁴ See Gordon Hughes and Timothy Murray in particular.

⁵ Unfortunately, Richard Howard's translation of Barthes's caption here is both poetically tone-deaf and grammatically inaccurate. Barthes's caption is an obvious allusion to and re-writing of the central line in Baudelaire's poem '*La Vie antérieure*', '*C'est là que j'ai vécu*'. Barthes retains the first part of the citation '*C'est là*' ['It is there'] but changes the tense of the verb *vivre* (to live) from the *passé composé*, which normally denotes completed action in the past time, to the conditional tense. The conditional is often used (as it is here) as a virtual potential reserve for a (desired) but unrealized, and essentially unrealizable, future action. Howard's published translation, 'I want to live there', transforms the conditional tense into a direct present indicative thereby removing the entire tension surrounding the temporality of life itself in Barthes's poetically photographed sentence.

⁶ Determining the precise source of the Freud quotation in Barthes's text is actually even more complicated. The French edition of *La Chambre claire* which, unlike the English edition, includes Barthes's bibliographical references in the margins, indicates that Barthes probably does not quote Freud directly. Instead, he copies the Freud quotation from an article by Jean- Thibaudeau and Jean-François Chevrier entitled, '*Une inquiétante étrangeté*', in *Le Nouvel Observateur, Spécial Photo*, no. 3 June, 1978). Here is the quotation (and the commentary on it) as it appears in

the Thibaudeau and Chevrier: '*Qu'est-ce qu'un paysage? Selon Freud, dans les rêves, une représentation des organes génitaux, et au bout du compte du corps maternel, comme lorsque la vision s'accompagne d'un sentiment de "déjà vu"* — *"il n'est point d'autre lieu dont on puisse dire avec d'autant de certitude qu'on y a "déjà été", sentiment composé d'attirance et d'effroi, qu'il nommera l'inquiétante étrangeté.*' They have combined and collapsed the two Freud texts into one. They have also introduced the notion of attraction and horror here.

7 For example, in *The Psychopathology of Everyday Life*, he writes: 'To put it briefly, the feeling of '*déjà vu*' corresponds to the recollection of an unconscious phantasy.' Sigmund Freud, *The Standard Edition of the Complete Psychological Works*, trans. James Strachey (London: The Hogarth Press, 1966), vol. VI, 266. All subsequent references to Freud will refer to this edition and will be indicated by *SE* followed by the relevant paper title, volume and page numbers. For a compelling discussion of 'déjà vu' in Freud's work, see Nicholas Royle, *The Uncanny* (Manchester: Manchester University Press, 2003), 172–186. In his chapter 'Déjà Vu', Royle performs a brilliant analysis of the relationship between the (mostly repressed) figure of 'déjà vu' as it appears in *The Uncanny* essay and its relation to the 'landscape dream déjà vu' passage from the *Interpretation of Dreams*. Royle observes: 'If, as Freud maintains, "there is indeed no other place about which one can assert with such conviction that one has been there before", it may be equally valid to maintain that there is no other place about which one can assert with such conviction that one cannot possibly know what one is talking about in supposing that "one has been there before"' (p. 181).

8 In their essay, 'Notes on Love and Photography', in *Photography Degree Zero: Reflections on Roland Barthes's Camera Lucida*, ed. Geoffrey Batchen (Cambridge: MIT Press, 2009), 105–140, Eduardo Cadava and Paula Corbès-Rocca also call attention to the mother's body as dark room. They write: 'The condition of possibility for a process of reproduction that gives something to be seen, the mother's body is at once camera, developer, and photographic darkroom. Giving birth to an image, the mother is another name for photography'. Cadava and Corbès's essay performs a notably loving and affirmative reading of photographic maternal love in Barthes's book. While I admire the virtuosity of many of their insights, I remain somewhat more reticent than they about the specific range of positive possibilities they accord to Barthes's conception of photographic love, survival, and futurity.

9 Sigmund Freud, 'Negation' (1925), *SE*, XIX, 235.

10 For a sustained discussion of photography and the maternal function in *Camera Lucida* with a slightly different focus, see my essay 'Nothing to Say: Fragments

on the Mother in the Age of Mechanical Reproduction', in *Esprit Créateur* 40.1 (2000): 25–35.

[11] Although this point exceeds the scope of this essay, I would like to remark that throughout his essay on Barthes as well as in many of his subsequent writings dealing with photography, Derrida often uses language associated with an interrogation of birth (and/or the maternal function) even when ostensibly writing explicitly about death. Thus, for example, in the very recently republished and newly translated *Athens, Still Remains*, Derrida writes about a sentence-phrase, 'we owe ourselves to death' ['*nous nous devons à la mort*'], that comes to him, photographically, 'like an original — or a negative without origin.' Describing this photographic sentence, he writes: 'We owe ourselves to death. This sentence was right away, as we have come to understand it, greater than the instant, whence the desire to photograph it without delay in the noonday sun ... An untranslatable sentence (and I was sure from the very first instant that the economy of this sentence belonged to my idiom alone, or rather to the domesticity of my old love affair with this stranger whom I call the French language), a sentence that resists translation, as if one could only photograph it, as if one instantaneously had to take the image by surprise at its birth, immobile, monumental, impassive, singular, abstract, in retreat from all treatment, unreachable in the end by any periphrasis, by any transfer, by rhetoric itself, by the eloquence of transposition' (*ASR*, 13–16).

[12] Throughout this essay, I have also been trying (albeit obliquely) to engage Derrida's writings on photography to help me think about how to understand the specific status of the 'unconscious' in Walter Benjamin's famous, but perhaps insufficiently understood, concept of the 'optical unconscious'. For his most sustained discussion of the 'optical unconscious', see Benjamin's 1931 essay 'Little History of Photography', in *Selected Writings*, vol. 2, eds. Michael Jennings, Howard Eiland and Gary Smith (Cambridge: Belknap Press of Harvard University Press, 1999), 507–530. Benjamin writes: 'For it is another nature which speaks to the camera rather than to the eye: "other" above all in the sense that a space informed by human unconsciousness gives way to a space informed by the unconscious. Whereas it is a commonplace that, for example, we have some idea what is involved in the act of walking (if only in general terms), we have no idea at all what happens during the fraction of a second when a person actually takes a step. Photography, with its devices of slow motion and enlargement, reveals the secret. It is through photography that we first discover the existence of this optical unconscious, just as we discover the instinctual unconscious though psychoanalysis. Details of structure, cellular tissue, with which technology are normally concerned — all this is, in its origins, more native to the camera than the

atmospheric landscape or the soulful portrait. Yet at the same time, photography reveals in this material physiognomic aspects, image worlds, which dwell in the smallest things — meaningful yet covert enough to find a hiding place in waking dreams, but which, enlarged and capable of formulation, make the difference between technology and magic visible as a thoroughly historical variable.' (*SW*, vol. 2, 510–512). Although Derrida (and Eduardo Cadava following him) have pointed to the common historical moment that is shared by both psychoanalysis and photography and to the specific analogies that can be established between photography and psychic processes, the specifically historical dimension of a 'photographic unconscious' unbound from the notion of a psychological subject still remains to be thought. Derrida refers to Benjamin's writings connecting photography and psychoanalysis on numerous occasions including 'The Deaths of Roland Barthes' and *Right of Inspection*, trans. David Wills (New York: The Monacelli Press, 1998). For an excellent discussion of this question, see Eduardo Cadava's chapter 'Psyches,' in *Words of Light*: *Theses on the Photography of History* (Princeton: Princeton University Press, 1997), 97–101. Specifically addressing the status of the unconscious, Cadava writes: 'The photograph tells us that when we *see* we are unconscious of what our seeing cannot see. In linking, through the photographic event, the possibility of sight to what he calls "the optical unconscious", to what prevents sight from being immediate and present, Benjamin follows Freud, who, in his own efforts to trace the transit between the unconscious and the conscious, often returns to analogies drawn from the technical media, and in particular from photography' *WL*, 97.

[13] From a psychoanalytic perspective (as Barthes knows well) the fascination with an image of the parents prior to one's own birth clearly conjures up the deferred (and implicitly photographic) temporality of the 'primal scene': '*Nachträglichkeit*'. For a discussion that includes mention of the photographic aspect of the primal scene, see my essay 'The Sexual Animal and the Primal Scene', in *Sexuality and Psychoanalysis: Philosophical Criticisms*, eds. Jens de Vleminck and Eran Dorfman (Leuven: Leuven University Press, Forthcoming 2010).

[14] To my knowledge, I am one of the few critics who have called attention to it. See my 'Flat Death: Snapshots of History', in *Dead Time: Temporal Disorders in the Wake of Modernity* (Stanford, CA: Stanford University Press, 2001), 86.

[15] It seems that Barthes inscribes a kind of subliminal narrative about the 1850s — that is, the inaugural period of the Second Empire and the historical period that coincides with the birth of photography. In this context, it is interesting to note that, as Diana Knight observes: '"*La Vie antérieure*" and "*L'invitation au voyage*" were first published in 1855, which makes them exactly contemporaneous with

Clifford's photograph, dated as 1854 in the text, and as "1854–1856" beneath the reproduction'. In *Barthes and Utopia: Space, Travel, Writing*, 221.

[16] Here I am thinking of texts like the film *Blade Runner* (directed by Ridley Scott), in which the android 'Rachel' ultimately establishes her 'humanity' by attempting (and failing) to document that humanity by presenting photographs of her (non-existent) mother. See my article 'Blade Runner's Moving Still', in *Camera Obscura*, 27 (1991) 77–87. In my forthcoming book, *The Mother in the Age of Mechanical Reproduction: Psychoanalysis, Technology, Literature*, I explore the psychic ramifications of the relationship between mechanical reproduction and the maternal function.

[17] This section of this essay is loosely based on a text on Cixous and photography that I originally wrote in French for a conference (organized by Marta Segarra) devoted to the work of Hélène Cixous in Paris in 2008. The French conference paper will be published as '*Photolectures*', in *Hélène Cixous: Croire Rêver — Arts de Pensée*, eds. Bruno Clément and Marta Segarra (Paris: Editions Campagne première, 2010), 190–199. I would like to thank Geoffrey Bennington for help with the English translation. For a beautiful reading of the figure of 'light writing' in Cixous that runs parallel to the one presented here, see Michael Naas, '*Flicker: réflexions à la lumière de sa veilleuse*', in *Hélène Cixous: Croire Rêver — Arts de Pensée*, 169–181.

[18] Hélène Cixous, *So Close*, trans. Peggy Kamuf. (London: Polity Press, 2009), 3. All subsequent references to this book will be indicated by *SC*, followed by the relevant page number. For the original French edition, see Hélène Cixous, *Si près* (Paris, Editions Galilée), 2007. This edition will be indicated by *SP* followed by the relevant page number.

[19] Hélène Cixous, *Osnabrück* (Paris: Des femmes, 1999), 37. My translation.

[20] Over the last several years, there has been a veritable explosion of interest in Proust and Photography. Here it bears mentioning that in Roland Barthes's posthumously published seminar, *La Préparation du roman* (Paris: Editions du Seuil, 2003), Barthes includes a section called '*Proust et la Photographie*'. For a discussion of this final seminar, see Kathrin Yacavone, 'Reading Through Photography: Roland Barthes's Last Seminar "Proust et la Photographie"', in *French Forum*, 34.1 (Winter, 2009) 97–112. Among the many recent critics who have been working on Proust and Photography (or photographic issues in Proust), see, in particular, Mieke Bal, *The Mottled Screen: Reading Proust Visually*, trans. Anna Louise Milne (Stanford, CA: Stanford University Press, 1997) and Elena Gualtieri, 'Bored by Photographs: Proust in Venice', in *Photography and Literature in the Twentieth Century,* eds. David Cunningham, Andrew Fisher and Sas Mays (Newcastle Upon Tyne: Cambridge Scholars Publishing, 2005), 25–41.

[21] Hélène Cixous, *Benjamin à Montaigne: il ne faut pas le dire* (Paris: Editions Galilée, 2001), 78–84. All translations to this book were done by me with the help of Geoffrey Bennington.

[22] Hélène Cixous, *Reveries of the Wild Woman: Primal Scenes*, trans. Beverley Bie Brahic (Chicago: Northwestern University Press, 2006), 84.

[23] Hélène Cixous, *Manhattan: Letters from Prehistory, trans. Beverley Bie Brahic* (New York: Fordham University Press, 2007), 112.

[24] As Derrida points out in 'Freud and the Scene of Writing', Freud often invokes photography to describe the relationship between conscious and unconscious processes. See Jacques Derrida, 'Freud and the Scene of Writing', *Writing and Difference*, trans. Alan Bass, (Chicago: University of Chicago Press, 1978), 196–231. Derrida cites Freud from 'A Note on the Unconscious in Psycho-Analysis' (1912) where Freud writes: 'A rough but not inadequate analogy to this supposed relation of conscious to unconscious activity might be drawn from the field of ordinary photography. The first stage of the photograph is the "negative" every photograph picture has to pass through the "negative process": and some of these negatives which have held good in examination are admitted to the "positive process" ending in the picture' (*SE*, XII, 264).

[25] Hélène Cixous, *L'Amour du Loup et autres remords* (Paris, Editions Galilée, 2003), 143. My translation.

Melville's Couvade

David Farrell Krell

Keywords: Photography, Herman Melville, couvade.

The bonethin man with thinning hair and bottlebottom eyeglasses —
fearsome spectacles that made his frightened eyes pop out at every
passerby who saw him trudging toward the Trieste Public Library —
entered the stately building and proceeded to the reference room; there
he located the appropriate *C*-fascicules of the impending reedition of
the *Oxford English Dictionary* and transported them to an unoccupied
table in the least accessible corner of the room. The bonethin man
was both grateful and irritable. Grateful that the library possessed not
only Littré and Grimm along with the standard Italian dictionaries
but also the multivolume OED, the queen of dictionaries in any and
every language, but unnerved and irritable and even abashed because
he had never come across the word before, even though his French
was passable, no, much better than passable. He flicked the pages
with impatience, leaving *cot-* behind, backing up from *cov-*, until he
found the proper page. And now his frogeyes hopped from entry to
entry in this particular corner of the penumbral lilypond of the English
language until they alighted on the new word, the upstart word. Had
he learned of its existence only a few months earlier he would have used
it for the trial of Bloom in Nighttown: Bloom, the new womanly man
who, highgrade hat over pudenda, so wanted to have a baby.

 Couscous... Cousiness... Couthie.... And there it was, in fact.
Couvade. The bonethin man swallowed the wave of indignation that
rose in his gorge. He must have grunted or harumphed because the
assistant librarian turned from his task of dusting with a gaily decorated

The Oxford Literary Review 32.2 (2010): 271–289
Edinburgh University Press
DOI: 10.3366/E0305149810000787
© The Oxford Literary Review
www.eupjournals.com/olr

handkerchief the tops of the tomes on the shelves to deliver a gentle shush of reprimand. That only made matters worse. The bonethin man squinted fiercely through his bottlebottom lenses, becalmed himself as best he could without running through the initial decad of the ordinal numbers, whereupon, slowly, deliberately, he submitted to the ancient discipline of all the jesuitical colleges he had attended in his life. Interrogatingly he deciphered the entry.

Couvade = couvée or *couvement*. From *couver*, to hatch, brood, sit on eggshells, liberate chicks. *Faire la couvade*: to cower or skulk indoors while the plucky lads go off to battle. A term of derision. For some. For others the better part of valour. For the new womanly man the male childbed attributed to some uncivilized or primitive races; a series of customs by which, preliminary to or consequent upon the birth of a child, the father performs acts or simulates states natural or proper to the mother, or abstains for a time from certain foods or actions, as though he were physically affected by the impending or actual birth.

<div align="center">The Citizen</div>

— Call that a man?

And which primitive, uncivilized peoples would these be? inquired the bonethin man of the fascicules. Celts, perhaps? Hibernians? Ah, yes, the Béarn and Basque districts of the Pyrenees, as reported by Strabo the cross-eyed Hellene, the ancient geographer who gave us the word *strabismus* and who could not readily distinguish east from west. Easy, easy. Beware ricochet, beware recoil. Where else, this male childbed? In West Yunnan Province, of course, as recounted by Marco Polo in the 13th century. And? In the native American Indian camps of the Upper Michigan Peninsula of North America during this the early 20th century. Elsewhere in the New World, perhaps? Ah, yes, one additional presumptive case of couvade was reported in mid-19th-century Pittsfield, Massachusetts, New England, North America, Western Hemisphere, the Earth, the Solar System, the Milky Way, streaming through the small heap of 30 galaxies that are neighbor to the larger Virgo heap of 2,500 galaxies in the as yet ever-expanding Universe.

•

Professor Hershey Bulkington too was irritable. He pulled his uncushioned wooden chair up hard behind him. The paper he had finished the night before for the Old Dartmouth Historical Society New Bedford Whaling Museum at Johnny Cake Hill lay as a neat stack of pages on his desk. It had not been so difficult to write. A lifetime of research on America's greatest writer had provided whatever facts and figures he needed. What made him irritable was Frances. Melville's daughter. The fourth child, born on March 2, 1855. March 2nd? What star-sign would that be? Such a bull-headed child! Ram, maybe?

Oh, the ingratitude of children! After all we fathers do for them! Hershey could have added a note on *King Lear* to his paper, but it was already too long. He had packed as much as he could into it, compressing, simplifying, extruding. Only a few issues needed rethinking. If Frances would give him a moment's peace.

He let the whole situation swim across his mind once again: Melville, damned by dollars, or by the lack of them, juggling his debts to family and friends, borrowing from the one in order to pay the other, hoping his novels would sell well enough to enable him to stop this infernal juggling. *Pierre*, published a year after *Moby-Dick*, was the unmitigated disaster. A self-inflicted wound, one had to say. How did Melville ever expect a book about incest to sell in America, where not even normal sex was tolerated? Pierre, with a mother he calls 'Sister' and teases as a lover, living with his jealous half-sister, his besotted former fiancée, and a ruined third woman — did Melville really expect this book to grace the shelves of the stern Pittsfielders and make him solvent? Things went downhill fast for him after that. By 1855 a full-blown crisis was brewing. By the end of that year he'd be writing *The Confidence-Man*, the book that would spell the end of him. 1855, yes, that was the year of the early onset of the protracted end. His sister Kate was six months pregnant and his wife Elizabeth was even farther gone. Another Melvillean mouth or two to chowder down. Hopeless.

Hershey Bulkington flipped through the stack of pages until he found the paragraphs that might need reworking. His index finger ran down the page that told of Melville's collapse in February 1855. Melville took to his bed. Could it really have been rheumatism?

Sciatica? Can Elizabeth's account be trusted? Why, really, did he take to his bed? Hershey's index stopped at the sentence that was clearly too speculative. He read it carefully once again, for the umpteenth time: 'The timing of the attack suggests the possibility of couvade, because his wife gave birth to her fourth child, Frances, on March 2, 1855.'

It was an odd word. Perhaps he should explain its meaning? Perhaps he should figure out what in blazes he was thinking when he dredged it up from devil knows where!

Hershey's eyes zig-zagged farther down the page, where his speculation had swelled beyond all proper proportion. He remembered having pulled off the shelf the volume that contained 'The Tartarus of Maids' in order to find his metaphor for the passing of the months in Kate's and Elizabeth's pregnancies, months marked by the unstoppable swelling of the bellies of sister and wife. Hershey had speculated that these burgeoning bellies, ballooning toward full term, could not but have reminded Melville of the due dates of his interest payments, obligations old and new that he would not be able to meet. Hershey checked the 'Tartarus' quotation to make sure he had gotten it right: 'But what made the thing I saw so especially terrible to me was the metallic necessity, the unbudging fatality that governed it.'

The words were correctly copied, but Hershey hesitated. Could he really equate the 'thing', the 'it', with the gestation process? Metallic necessity in a woman's womb? The 'it' in Melville's story was, to be sure, nothing organic at all, but the monstrous paper-making machine to which the factory girls were attached, 'glued to the pallid incipience of the pulp'. Could Hershey get away with it? Jacobson would tear off his arms and legs in the name of the proletariat, Strawson would clip the remaining parts, and he was too old to be meat for Marxists or Maenads. Literature had become a life-threatening business of late; he was glad to be putting down the pen. Even so, he thought about what fun Strawson would have with 'the pallid incipience of the pulp' and he smiled. After all, the Tartarus of maids, located beyond Woedolor Mountain, was operated by girls who were not yet women, with 'Cupid' as the narrator's tourguide. Wasn't that Melville all over! Hershey decided that his metaphor was safe: he could take whatever the Marxist or the Maenad would dish out and toss it right back at them. With metallic necessity! He chuckled. Then he frowned. His thoughts had returned to Frances.

The Melvilles' fourth child never forgave her father for the poverty to which his high-falutin' literature had condemned them all, and she never forgave him for the suicide of their firstborn, her brother Malcolm, nor for Bessie's illness nor for Stanwix's wasted life. She told her own children about these things so that the family would preserve Melville's reputation as a crazy, self-centered old coot. If it was couvade — that collapse early in 1855, when Frances was still in her mother's womb — then her subsequent defamation of the man who for her sake had capitulated to the absurd confusion of male parturition certainly was the cruelest of ironies. Who could have foreseen the author of *Moby-Dick* foundering in such befuddlement? And who could have foretold that all his labor and his birth-pangs would bring forth such a scorpion, such a rough beast?

Hershey Bulkington let his imagination go, although he did not uncap his pen. He would not commit to paper what he was seeing and hearing now, as Melville begged Frances, speaking to her not through the membranes and the soufflé of her mother's belly but in silent and desperate whisperings down through his own diaphragm and peritoneum to his own hysterically wandering womb as he lay incommoded in woedolor childbed.

— Forgive me, child, he pleaded, for this and for everything to come: for Malcolm, for Bessie, for Stanwix, for Fayaway and Isabel, and for all the latenight proofreading I asked you to do.

— Never, she replied.

•

Isabel had been Daniél's favorite model, for reasons one can imagine, and when he had to leave Prague for reasons beyond anyone's imagination he married Isabel and took her with him to Germany. Isabel soon became pregnant, for reasons one can perfectly well imagine, and Daniél made certain that he could be present at the birth of their little girl. The German hospitals had developed a new program that encouraged husbands or partners to be present at the birth; the spouses were given tasks to perform throughout the labor and delivery so that they would be too busy to faint. Only at the end of the birth process, well after adequate dilation had been achieved and not long after the chief physician had performed the episiotomy, that is,

only when the crown of the infant's head appeared, were the husbands permitted to drop their tasks and enjoy the show.

And what a show it was. Dilation was too weak a word for what Daniél saw. Isabel had managed, through the most patient of nocturnal labors, hour after grueling hour, to stretch her birth canal — no longer a vagina, yet in the precise place where she had kept her vagina — to a point vastly beyond mortal powers of imagination. Now, in the delivery room, amidst a great deal of activity, Daniél observed at the center of Isabel's distended Panama and Suez the apparition of what seemed to be a swollen organ, black and bloody, an organ that Isabel would doubtless need to retain if she were to live on.

— O my god! cried Daniél. Is that her liver, doctor?

The midwives laughed out loud and even the obstetrician smiled.

— That, my friend, is your daughter. She's got a full head of black hair.

— My wife has black hair, Daniél explained, and the midwives laughed again. Even Isabel laughed in the midst of her gruntings and pushings.

— Stop saying stupid stuff! I've got to concentrate! she cried.

Once the head was clear the doctor turned the infant onto its side, clearing the shoulders. Isabel had opened so astronomically, so far beyond the powers of divine imagination, that the baby came bouncing out in a final burst and swoosh.

The doctor held the sides of the head between the palms of his hands and lifted little Lina — for that is who it was — into the air. Lina's open eyes moved left and right, then fixed on Daniél's gaze. She did not cry. She had her mother's eyes as well. Daniél spoke to her.

— Hello, Lina, he said.

The labor had taken twelve hours, almost all of them spent waiting through the long night for the dilation. Before the birth, Daniél had wondered why, as all the books confirmed, it would take so long. After the birth, he could not imagine how quickly such a snug embrace could turn into a maritime thoroughfare. He thought about this metamorphosis confusedly in the state of euphoria that enveloped him as he left the hospital and headed home. Before he collapsed into twenty hours of uninterrupted yet by no means dreamless sleep

he thought about Isabel, about their unlikely romance after a strictly professional relationship back in Prague, about their new life now, and about that unimaginable waterway of life. It was something that, for all his expertise, he would never have been able to predict.

•

Daniél had been a student of photography at the Prague School of Fine Arts, an exceptionally gifted student from the start of his studies at age nineteen. At twenty-one his Uncle Alfons drafted Daniél into the family business, which was the maintenance of the technically if not artistically most highly developed porn site in the Czech Republic. By twenty-three Daniél had become The Maestro. He had barely found the time to complete his final-year portfolio for the art school, a portfolio that contained other sorts of photographs — bridges, buildings, old men, and children with bright faces.

Uncle Alfons had been difficult at first. Having set Daniél up in a state-of-the-art studio on the second floor of a building well-situated on the Clock Square, he began to send his star-studded cast to his nephew, who proved to be uncooperative. Most of Uncle Alfons's regulars refused to return after a single session with Daniél. Uncle Alfons would not have put up with such artsy-fartsy airs had the boy not been so phenomenally successful. The Internet subscriptions poured in as never before.

Daniél had gone in search of his own models, however, finding them not in topless and bottomless bars but in the Music Conservatory and the School of Fine Arts itself. Former classmates and a teacher were his first and best subjects. He invited them for coffee and poppyseed cake at the Café Louvre. He took long walks with them through the castle and its gardens or through the house on the Burg where Kafka lived with his sister Ottilie. Later on Daniél would pay for their time. Right now he explained what he needed them to show, and why they needed to show it to him. He seemed to be making a religion of it and they seem to have been converted.

Isabel, a gifted painter at the School, was one of his first. It turned out to be impossible for him to select a series from the thousands of black-and-whites he made of her (he photographed only in black-and-white and printed only on Ilford paper, although he used a digital camera as well, for Uncle Alfons's sake) because they were all so

exceptionally beautiful. If they were not beautiful it was because he had fumbled. Isabel insisted that the beauty was his doing, but he knew otherwise.

— Every girl's got what I've got, she laughed.
— You're wrong, cried Daniél vehemently.

Daniél's mastery consisted in his photographing with fanatical focus and well-nigh sybaritic fervor that portion of a woman which preachers and roués proclaimed to be uniform and identical in all women. Daniél became a master of the differences, some remarkable, some subtle, some infinitesimal. He taught his cameras how to discern and record these differences, his lamps how not to flatten and insult them, his chemicals and his computer programs how not to burn them; he prepared his paper and his software to receive the rarefied differences and he made certain that his airbrush left them alone. His dream, the hope that undergirded his faith, as it were, was to enable everyone to see these differences and to know all the faces and folds of the sacred.

He tried not to use that word. It would only frighten Uncle Alfons's clientele and unnerve the models. Isabel had come closest to accepting Daniél's fervor, although even she had difficulty suppressing her skepticism and her sense of humor. Her laughter had become an issue between them.

— I have a sense of humor, Daniél said in his own defense.
— Not about this you don't. You never make stupid jokes. You are never vulgar. You never come on to me.

Daniél was arranging the lights and her legs.

— I never come on to anyone. I'm a professional.
— That doesn't seem to stop the other professionals, Isabel said with an edge.
— I can't speak for them, said Daniél.

He was shooting now from the side, up her raised left thigh, across the mountain, out along the other thigh. A near-perfect 180°.

— Are you comfortable? he asked.
— I'm about to split up the middle, she groaned. Can you move it along?

Daniél worked quickly now, snapping dozens of back-lit shots, then moving to the other side for dozens more, front-lit. You never knew for sure till you were in the darkroom, but he felt certain about these.

— Okay, we're done.
— Oh, God, my hips! I'll never walk again! Can I rest here a moment?
— Take as long as you like, I have to change lenses.

As Daniél switched lenses on both cameras he glanced down at Isabel. She was sitting on the edge of the table, her legs now closed, her bare feet dangling; she was rubbing her hips and thighs, her jet hair a swaying satin curtain hiding her face. He tried hard to be very professional.

— If I ever came on to any of my models it would be you, he said.
Isabel stopped rubbing and swept the curtain back. She wore a smile he had not seen before. The smile widened. One eyebrow arched.
— Ah, the professional is a Romantic! And why would it be me?
— You have the most perfect sex I've ever seen.
— And here I thought it was my wit and charm.
— That is your charm. Even your wit.
— Some women would find that insulting.
— You are smart enough not to be insulted by it.
Isabel slipped carefully off the table and into her robe and slippers.
— Can I ask you something? she said quietly.
— Of course.
— You've taken hundreds of pictures of me . . .
— . . . Thousands . . .
— Okay, thousands. But even though we've agreed on which ones are the best, you've never really taken me through them.
— You mean?
— I mean . . . You say I'm beautiful, in my sex. But you don't tell me why, or how.

Daniél nodded. He walked to the huge metal filing cabinet and removed the 'Isabel' file. In the thickest subsection of that file, which had its own special label, he found what he was looking for. He began to spread the large prints across the table. His hands could feel the

warmth of her body rising off the oak. Her warmth moved him in a way to which he was not accustomed. Most people would not have identified such warmth with religion, but for him it was the essence of religion, felt only on the rarest of occasions. He allowed the feeling to wash over him like a wave of the sea. Isabel stepped up close behind him. At that instant each of them felt that they had never been closer, even though the prints on the table suggested otherwise.

— I call you 'The Hooded Phantom', he said.

He showed her the label. Isabel laughed and touched the back of his shoulder, as though to support herself as she leaned in to look. When she studied the treasures on the table she could see what he meant. She had opened so wide for that series too that her outer lips had become one with her thighs — only the slightest ripple of ridge showed where her sex began. Her inner lips formed a perfect oval, or almost a perfect oval, more the shape of a single leaf of Belgian endive, a frame of darker tissue surrounding the luminous center. The inner tissue at the base of the leaf lay in deeper shadow, as though this were the mouth of a cavern. At the top of the leaf a second hood appeared, the hood, she knew, that sheathed her clitoris.

— So which hood do you mean? Over my vagina or over the lovelump?
— Your lovelump? laughed Daniél.
— My goodness, you do have a sense of humor. But which hood? and where's the phantom?

Daniél didn't reply, but he pointed to one of his favorite shots. Isabel's face appeared at the top of the print. She was lying on her back, her legs and head raised. Reaching behind her leg, her left hand stretched open her major labia while the right pinched the clitoral hood between thumb and index and lifted it. The elongated hood above the wider hood of her vagina made a perfect cowled monk, and Isabel said so to Daniél.

— A Cistercian, he said.
She gave him a playful slap on the shoulder but kept her hand there.
— Maybe it's not a monk, she said. It looks like a statue of Maria — her hands are folded over her breast, her head is veiled.

— Her face is averted. But not yours. Look. Your mouth is open, your look is focused. We can see that you are working, working hard, though with agility. Your fingers are very skilled, very adroit, very... beautiful.

— Years of practice, laughed Isabel. But which hood do you mean? You still haven't said.

— That's why I've been taking side shots today, across the top, so that the upper hood comes out more clearly.

— My lovelump hood?

— Your lovelump hood.

— This shot from above — your camera must be over my navel — shows it best. But what a terrible shave-job! I have to change salons.

— No, the hair is holy, said Daniél, with no trace of irony.

— Stop it, said Isabel halfheartedly. But look how bright I am on the inside in this one!

Daniél noted that he had gotten the contrast right, the brilliant mucous whites against the darker corrugated frame of the inner lips, the clitoral hood all lambent liquid light. The contours were soft, as they should be, and even the gooseflesh of the buttocks that were barely out of focus below was incredibly soft. He had been very close to her for this shot, bending over her belly. He remembered. She had smelled very lightly of woman.

Daniél pointed to a photo at the edge of the table.

— And here's 'The Phantom' himself.

— Are you sure it's a guy?

— Looks like a guy to me.

— He's so shiny! and so shy! I mean *she*. What do you think made her come out that day?

— I wanted to see her. I asked you to show her to me, don't you remember?

Isabel's hand tightened every so slightly on Daniél's shoulder. She lowered her voice in parody of his earnestness.

— I'm a professional. If my photographer demands a showing, I give him a showing. Still... she seems very happy... to be out there in the world.

— Very plump, very full... almost swollen....

— No, not swollen, but very happy.
— I'm glad she's happy, said Daniél.

Isabel waited a long time, giving Daniél the space in which his own words might echo back to him, before she decided she would brave the last word.

— I think I'm beginning to understand this religion of yours, she said.
— The point is not to understand but to believe.
— Yes, but something sad holds me back.
— ?
— If only *you* had something like a hooded phantom it would be heaven itself. It would be something we could share.

•

Yet not all was sweetness and light with Daniél's faith. As with all religions in the history of humankind there had been Inquisitions and wars. With that bodybuilder, for example, the one who, Daniél knew full well, was behind his and Isabel's need to flee westward. Bärbel was her name, but Daniél had rechristened her Barbell, then Bella.

She had sought him out, not he her. They had agreed on a modest honorarium for her. She was going make a career of popping muscles and whatever else on her that might go pop. She had brought a Christmas-tree stand with her to their first session, sporting not a Christmas tree, however, but the most impressive dildo Daniél had ever seen, ribbed and mighty.

— You're wondering what I'm going to do with this, aren't you?
Daniél said that he had some idea.
— Have you got a stool?
Daniél pointed.

After the session, which had dragged on and on, Daniél studied the results. All that wasted film! The look of initial discomfort and eventual triumph on her face as the ribbed metal ersatz Christmas tree vanished — these shots were useless. Daniél scrutinized the body that strutted out of these prints: the manly shoulders, the manly smirk, the tapered thighs swelling in the middle like Doric columns, the belly flat and ribbed like that of a Doric athlete, footballer calves, obedient

breasts small and high, the nipples squaring off in parade. Square nipples? Daniél squinted. It was so: the aureoles were surrendering their roundness and growing angularly, fearfully symmetrical.

And her sex? That was all Daniél wanted for his art and his conventicles; her sex could have compensated for all the rest and saved the session. Yet whether from the front or torqued to the side it was all the same: to Daniél's practiced eye her sex appeared to be lunging to escape her torso. It was the one muscle she had not been able to discipline. The striated struts of her abdomen, stretching down to the vast mountain and gripping it firmly, failed to hold the rest. The outer lips gaped, even though her legs were almost closed, the inner lips, oddly cantilevered, bulging at the bottom, akimbo at the top, all but tumbled out. Daniél shivered. He could donate these shots to the medical school, but neither he nor Uncle Alfons would be able to use them. Why had he agreed to a second shoot? Useless. She had given him no telephone number. He would have to wait for her to show up in order to explain. She would not be happy.

She was not happy. She had brought more toys and some sad costuming. She was half-undressed by the time Daniél found the words to begin.

— I'm sorry. This isn't going to work.
— What do you mean it isn't going to work.
— I'll pay you for the full session, but I really can't use you.
— Use me? What the fuck is that supposed to mean? You coming on to me?
— Oh, no.
— Faggot!

Bodybuilder tears were welling in her eyes. Daniél was both angry and undone. He shrugged. She struggled with buttons and zippers.

— Queer! Heartless bastard!

Her absurd platform shoes clomped out the door and down the stairs. Then they remembered the money and clomped back up the stairs. She snatched up the envelope and tossed it into her bag of toys. She glared at him.

— Cocksucker! Go fuck your Old Man!

Daniél could feel the anger rising in his gorge, a wrath he could not swallow, not because of her imprecations but because of the memory of what was spilling out of her so horribly. His mouth opened and out came the words he knew he should not say. This woman could make trouble for him, as any woman could.

— Look, it's not my fault your cunt is so unphotogenic.

The bodybuilder froze. She went white, then red, then white again. She settled for livid. Her mouth gaped but the fitting insults would not come. Tears streamed, mascara stained. Daniél knew he had to protect himself with a lie.

— Look, your sex is fine, it's fantastic. I just can't stomach your personality.

To his astonishment, this did not help. Only weeks later did he realize the full gravity of the mistake he had made. For it happened that the bodybuilder was in fact a moral creature, a genuine person, a spiritual essence, a child of God. Also a policewoman.

Within the month Daniél and Isabel had to set out for Berlin. A month after that Isabel was pregnant.

•

All through the day and the night Daniél dreamt of the Suez Canal. A classic ship of yesteryear, a two-masted schooner, plied its waters. Daniél, perched on a sand dune, could make out the name in proud white letters on the prow. She was the good ship 'Lina', at her helm the Hooded Phantom.

•

Professor Hershey Bulkington breathed in the salt sea air. He was unaccountably at peace. His lecture had gone well — a lively discussion always did him good — except for that stupid woman in the back who had tried to rehabilitate Frances. There was always one, wasn't there. But he had arrived early enough that afternoon to spend some time alone in the Seamen's Bethel. He sat in Melville's pew, on the exact spot, as he surmised, and gazed up at the ship's prow bursting through the front wall of the chapel — the fanciful pulpit, garlanded now in

greenery and white blossoms. His mind's ear listened once more to Father Mapple's sermon, 'Delight is to him!' Yes, shipmates, in spite of all, Delight!

Hershey rose and wandered along the walls of the church, reading once again the familiar memorials carved into a black-framed marble plaque:

> To the memory of Gilbert Jay, of ship Peru
> of Nantucket, was lost from a boat
> while in pursuit of a whale, 1822,
> aged 19 yrs.,
> Franklin Jay, mate of ship Pioneer,
> was lost from his boat
> while in pursuit of a whale,
> Nov. 22, 1832, aged 27 yrs.,
> Wm. H. Swasey, of sch.r T. Cash
> of Fairhaven Conn.
> was lost at sea, with all her crew,
> April, 1830, aged 39 yrs.
>
> *
>
> *They died, no loving heart was near,*
> *With kindly aid to soothe and cheer.*
> *Alone the valley dark they trod,*
> *Yet not alone, for there was God.*

— Lost while in pursuit of a whale, repeated Hershey Bulkington in a half-whisper. That could be said of Melville too, I suppose.

He read once again the simple, pious verse at the bottom of the memorial. For the Jays and the Swaseys there was God, reflected Hershey, but not for Melville, unless as an opponent in an interminable debate. Frances was partly right, after all. Her father certainly had a gift for making his life difficult for himself. Maybe for everyone else too.

— Maybe for me as well, he muttered.

Perhaps they all would have been better off if Melville had remained a recluse in the enchanted isles of the Galapagos, a hermit like old Oberlus on Hood's Isle, or maybe even like Oberlus's muddled, half-starved cock roosting on his desiccated, eggless nest. What strange books Melville had hatched! It had taken Hershey Bulkington an entire lifetime to read them. Yet now that the lecture was over and the familiar postpartum letdown too had passed he sucked into his lungs the salt sea air and was content. No one had pushed him on the question as to why Melville had taken to his bed. He would work on this some more. He wasn't quite finished yet.

•

As the narrator fell back exhausted into the arms of Karakoee the warrior-sailor of the Kannaka, the smallboat sped toward the waiting 'Julia' and salvation. The narrator, more than exhausted, feverish, delirious, fell into a swoon. It may have been the speed with which the bark was flying that ignited in his failing consciousness such a vivid vision of the past — of fair Fayaway on her skiff, doffing her tappa and letting the wind fill it like a sail, while she served as the naked, two-pronged mast. The narrator had studied the mast, not the calico sail. The darker buds against the dark olive skin of her breasts: the first word of Tahitian he had learned from her on Nukuheva had been the word for milk. Fayaway's legs were planted far apart on the skiff. Her mat of black hair came to a discrete point at her lips. She laughed in the wind. Her teeth flashed. The second word she had taught him was *love*, a word that in her primitive mind appeared to be perpetually confused with sex. And now the narrator was leaving her? Escaping in order to write, and perhaps to publish, his adventures? Did this make any sense at all? Was she not enough, fair Fayaway, with her laughter and her lips? Already Fayaway, the beautiful woman, eternal image of mating and childbed and increase, was beginning to fade away. The narrator collapsed in deeper prostration still. He sank and surrendered to the arms of the Kannaka warrior-sailor Karakoee.

•

Uncle Alfons sat dejectedly in the beer garden behind the John Lennon Wall of Prague with two of his Stars. Edgar, who was the wood, the

most reliable wood in Prague, sipped his Pilsner as the woman pleaded with Uncle Alfons. Everyone called him that. He was avuncular. But he would have to disappoint Tasha, his female star. He would have to disappoint them all.

— He's your nephew. He'll listen to you. Make me an appointment! demanded Tasha.

Uncle Alfons sighed in despair. He would have to find the right words to let them know of Daniél's flight. Diplomacy. Delay. Deception.

— Tasha darling, you are a film star, you don't do still-lifes, what are you, a bowl of peaches?
— Easy, easy, said Edgar.
— A bowl of peaches, why not? Peaches with cream! He's an artist, not a hack like you!
— A hack I am? A hack? After making you a star all over — Russia, America, everywhere!
— Easy, easy, said Edgar.
— You're just jealous of him. You know he'll shoot me better than you ever did. He'll make me beautiful!

Edgar, the reliable wood, could already hear what Uncle Alfons was about to say, which would be something not avuncular but offensive, yet his mouth was too full of beer to stop what was coming.

— The boy is not a miracle-worker, Tasha, said Uncle Alfons.
Tasha swallowed hard while Edgar choked.
— You're saying I'm not beautiful anymore? The biggest boobs the tightest twat in the Czech Republic and you're saying I'm not beautiful enough for your nephew?
— You're gorgeous, your perfect, you're my star! You're Edgar's favorite, isn't that so, Edgar.

Edgar choked and nodded. Bubbly Pilsner dripped from the twin taps of his nostrils. Tasha fumed. Uncle Alfons, the diplomat, dug himself in deeper.

— He uses different models, is all. You're not his type.
— You mean I'm too old.

— I didn't say that.

— Too old, too saggy, too sucked and fucked and tuckered out, is that what you're saying?

— Easy, easy, coughed Edgar.

— Daniél shoots only b&w. You need color.

— I need color because why? My bulge, my saddle ass? My razor-burned tookie, my gaping tush, why?

— You need color! Yes, yes, for all that, you need color!

— Easy, easy.

— See if I ever do it again in front of your camera, fucker! cried Tasha as she slammed the table with the palm of her hand and struggled to her feet.

Before their own reliable wood had time to remonstrate, and before Tasha could make her dramatic exit, both stars saw that Uncle Alfons had suddenly covered his face with his big hands. His shoulders were shaking with silent sobs. Edgar gaped. His choking subsided. Tasha sat down quickly, reached across the table and touched Uncle Alfons's arm.

— What's the matter, honey?

— I'm ruined! We're all ruined! sobbed Uncle Alfons.

He explained about Daniél's trouble with the police and his having run off to the West with one of his models. The three of them, aware of the financial implications of Daniél's desertion, contemplated the disaster.

Silence.

Time passed.

— But we've still got the Internet, said Edgar helpfully.

●

The raven-haired Jewish girl to whom years earlier the bonethin man with thinning hair and bottlebottom eyeglasses had given English lessons was on his mind as he quit the reference room. He remembered how she had finally emerged from her shell, calling him by his Christian name, teasingly reprimanding him. That had taken months to achieve, even though, if the truth be told, he had from the outset labored to

provoke that emergence. He had been in love with her. He had been infatuated.

— Ah, Giacomo, you are, I think, *cattivo*.

He remembered her words quite precisely. Her voice haunted his ear as he exited the library. It echoed in the labyrinth, played upon the porches, palpated ticklingly the tympanum of his ear.

Cattivo. 'Naughty'. No. Worse. 'Nasty'. If she had only known.

He walked slowly, his hands thrust deep into his pockets, the eyes behind his bottlebottoms conjuring up rather than apprehending the blurred cracks of the sidewalk, until he arrived at the foot of the hill where she had dwelled. Via San Michele. Flaming sword guarding the gate. His gaze rose in a haze to the grand house atop the hill. He would be leaving this city, her city, in a day or two.

If he had sighed, which he most certainly did not, why would he have sighed?

He would have sighed to think that lithesome beauty handily conquers age vanquishes wisdom routs prudence but that prudence wisdom and age will never, not even after the most strenuous and protracted efforts, win the heart of a maid.

He thrust his hands deeper into his pockets and trudged on. *Cattivo!* *Couvade!*

Reviews

Michael Syrotinski, *Deconstruction and the Postcolonial: At the Limits of Theory* (Liverpool: Liverpool University Press, 2007), 288pp. ISBN: 978-1846310560

Ben Grant

RE: RE: 'Deconstruction and the Postcolonial'

Deconstruction and the Postcolonial shares its title with an earlier essay by Robert Young, which situated Derrida as a Franco-Maghrebian writer, and deconstruction as anti-colonial.[1] Syrotinski agrees that deconstruction has much to contribute to a postcolonial politics. However, he is uneasy with the way Young locates the 'origins' of Derrida's thought in an anti-colonial genealogy, and with a wider tendency to reduce deconstruction's impact on postcolonialism to a series of 'reductive appropriations' (2). The purloined title therefore indicates both an overlap with Young's project, and a desire to rewrite it. The unoriginal origin of the book also performatively foreshadows its key motifs: repetition; splitting; spectrality; reinvention; debt; performativity itself.

In short, Syrotinski accuses Young of equating the two: deconstruction *is* the postcolonial. He sets out, instead, to retain the supplementary logic of the 'and', thereby to explore the 'liminal interface' (4) between them. That the book is divided into two parts is the most overt sign of the proliferation of doublings which this 'and' of his stolen title initiates. The first part centres on Derrida, Bhabha and Spivak. It begins with a critique of the elision, by Young and others, of the 'simultaneous double reading' (21) which Derrida's *Monolingualism of the Other* invites. This informs Syrotinski's alertness, throughout, to moments of ambivalence, which he keeps in play rather

The Oxford Literary Review 32.2 (2010): 291–302
Edinburgh University Press
© The Oxford Literary Review
www.eupjournals.com/olr

than closing down with a too quick reading. Thus, close attention is paid to a splitting in Bhabha's use of the term 'hybridity', which is frequently lost sight of in celebrations of the hybrid condition. Spivak's wide ranging encounter with Derrida, most notably played out in the exchange over *Specters of Marx*, is seen as a kind of family drama revealing 'the tensions of Spivak's ambivalent "debt" to deconstruction' (57). The second part of the book puts the theoretical framework of the first to work in Francophone African contexts, valuably expanding the scope of 'deconstructive postcolonial theory' (40). An excellent analysis of the fetishisation of Africa, revolving around Sembene's film *Xala*, leads into a wider consideration of the 'necessary doubleness' (89) of African subjectivity. This is explored through readings of Mudimbe and Mbembe. Although these writers do not engage with Derrida as directly as do Bhabha and Spivak, Syrotinski finds in their 'critical self-awareness' (92) and 'writing "otherwise"' (118) evidence of a deconstructive practice which can offer hope in contemporary Africa. The book ends by asking the question, 'Postcolonial Blanchot?'

The difference from Young is, at root, a difference in reading Derrida, which spreads outward, resulting in a surprising and elegant reconfiguration of the domain of deconstruction, postcolonialism, and the relationship between them. According to Syrotinski, Young takes Derridean terms and deploys them as concepts, while he is attuned to a 'complex interplay between singularity and universality' (16). He achieves this performatively, and his book, with its strategy of doubling, succeeds well in unearthing aspects of texts which a conceptual reading buries. He is less successful, I think, in keeping alive the difference between deconstruction and the postcolonial, tending, like Young, to run the two together, as in 'deconstructive postcolonial theory'. We could say that if Young inclines to place the 'deconstructive' under erasure, Syrotinski inclines so to place the 'postcolonial'. He does frequently gesture towards a postcolonialism which is *not* deconstructive, not least when he critiques Young's 'strong *postcolonial* reading of deconstruction' (11. My emphasis). Furthermore, his figuring of Spivak's 'debt' to Derrida as involving 'repetition and reinvention, fidelity and disrespect, thematization and performance, continuity and disruption' (57), taken with Derrida's failure to engage in any meaningful way with Spivak's work, is very suggestive in terms of the wider relationship between the two disciplines. However, these

threads do not sufficiently cohere to produce a sustained analysis of the *resistances* at work between deconstruction and the postcolonial. This would have required a greater readiness to 'read' resistance to deconstruction, rather than refute it. Therefore, while Syrotinski offers a convincing case for 'turning *back to*, and not *away from*, deconstruction' (118), I remain unsure why I might have felt, and might feel again, compelled to turn my back on it. That said, this impressive and playful book prompted me to think much more deeply than I have been wont to do about 'deconstruction and the postcolonial', and Syrotinski's sharing of another's title performs a most interesting and provocative experiment *At the Limits of Theory*.

DOI: 10.3366/E0305149810000799

Notes

1 Robert J.C. Young, 'Deconstruction and the Postcolonial' in Nicholas Royle (ed.), *Deconstructions: A User's Guide* (Basingstoke and New York: Palgrave, 2000), 187–210. A version of this essay appears as the chapter 'Subjectivity and History: Derrida in Algeria' in Robert J.C. Young, *Postcolonialism: An Historical Introduction* (Oxford and Malden, MA: Blackwell Publishing, 2001), 411–28.

Judeities: Questions for Jacques Derrida, ed. Bettina Bergo, Joseph Cohen, and Raphael Zagury-Orly, trans. Bettina Bergo and Michael B. Smith (New York: Fordham University Press, 2007), vii + 279pp. ISBN: 978-0823226429

Jonathan Judaken

This is a varied collection of essays. It is based on a conference of the same title that posed questions to Jacques Derrida around the theme of what the editors call 'judeities'.[1] Judeities is a neologism, plural of *judéité* (Jewishness), formulated to express

> a certain equivocation, an undefinable and undeterminable diversity.... [Judeity] grasped in all the variety of its interpretations and commentaries, its languages, its nationalities,

> its politics, philosophies, literatures, and religious
> currents.... [thus] simultaneously questioning what is
> understood under the term *Judaism* and interrogating the
> relationship (if there is one) between Jacques Derrida's
> writing... and those multiple judeities. (xi)

What results in this book is a group of essays by Derrida, Hélène
Cixous, and Jean-Luc Nancy among other central theorists of
deconstruction around a topic that emerged as a major *topos* in
Derrida's later work.

Israeli scholar Gideon Ofrat in *The Jewish Derrida* (Syracuse
University Press 2001) has shown that Derrida's whole oeuvre can be
read from a Jewish angle. But from *Circumfessions* (1991) onwards,
in a series of autobiographical texts, we find Derrida involved in an
intense and sustained engagement with the ontological investigation
of being Jewish, coupled ethically with a post-Levinasian responsibility
for the Other, itself tied politically to a notion of justices to be done
and injustices to be undone. These in turn are linked to a series
of key deconstructive themes, including hospitality, death, language,
translation and interpretation, and the secular/religious divide. *Judeities*
picks up on all of these topics and is thus an essential volume on
the shelf of Derrida scholars and students of deconstruction, as well
as scholars of (Jewish) intellectual history taken with these questions.
While the book as a whole strays in numerous directions, evidence of
the apparent undecidability of what the question of 'Judeities' meant
to the contributors, it includes some pivotal texts that will contribute
to defining the conversation around the 'Jewish Derrida' and Judaism
and deconstruction in the years to come.

The conference upon which the volume is based was held on
December 3–5, 2000 at the Jewish Community Center in Paris. The
proceedings were published in the Galilée series, 'La Philosophie en
effet' and thus explicitly endorsed by Derrida. But the English-language
edition contains only a subset of those essays originally included in the
French version, as well as a substitution by Hent de Vries of the piece he
presented in Paris. Still there are some gems here that are touchstones
for reflection.

Derrida opened the conference with an autobiographical piece,
'Abraham, the Other,' where he takes up and takes apart

'*three distinctions or alternatives*... (Jew/jew, authentic/inauthentic, Jewishness and Judaism)' that he states flatly are 'untenable' (17). He does so by interpreting his own life by the candle of these central categories that Sartre uses in his *Réflexions sur la question juive* (translated into English as *Anti-Semite and Jew*). Around this analysis, he inserts a series of caveats that the reader must bear in mind. Whenever Derrida reflects upon his being Jewish in a biographical vein — whenever he engages in what he calls in *Circumfessions* 'nostalgeria' — he always does so through 'detour[s]', 'calculated ruses', 'deliberate ellipses', 'by way of a phenomenological play of suspension, quotation marks and parentheses' in order to play 'a double game' (9). This is because he distrusts any locution that would fix an essence, an *eidos*, a *logos* to being Jewish.

This suspicion was instilled in the young Derrida from his childhood experience of expulsion from school at age 10, during the Vichy period, 'the highpoint of official and authorized anti-Semitism in Algeria' (15). The experience was so formative it makes him 'wonder whether the deciphering of the anti-Semitic symptom, as well as of the entire system of connotations that indissociably accompanies it, was not the first corpus I learned to interpret, as if I only knew how to read — others would say, how to "deconstruct" — because of having first learned to read, to deconstruct even, anti-Semitism' (15). The logic of identification and exclusion at the heart of anti-Semitism, sharpened Derrida's 'reasoned mistrust of borders and oppositional distinctions' pushing him to elaborate 'an ethics of responsibility, exposed to the endurance of the undecidable' (17). Derrida here thus countersigns interpreting the motifs of his Judeities as a refrain through his whole opus, from his earliest compositions on 'writing and the trace, [to] the relations between law, justice, and right... to the subject[s] of... messianicity without messianism... [and] the international beyond cosmopolitanism' (33).

But lest one move too quickly to connect the biographical details of Derrida's life and the methodological and thematic concerns of deconstruction, he urges mistrusting 'the *exemplarist* temptation' (16). 'Exemplarism', Derrida explains, 'would consist in acknowledging, or claiming to identify, in what one calls the Jew the exemplary figure of a universal structure of the living human' (12). Its logic is that 'The more Jewish the Jew [*plus le Juif est juif*], the more he

would represent the universality of human responsibility for man, and the more he would have to respond to it, to answer for it' (12). Derrida's direct critical target here is obviously Levinas, and more specifically Levinas' own writing on Israel, as Derrida made evident in his final celebration and critique of Levinas' work in *Adieu*. In opposition to this stance, Derrida's Judaic notes reverse the exemplarist formulation, maintaining in the legacy of the Marranos that 'the less you show yourself as Jewish, the more and better Jew you will be' (13).

To the extent that there is a leitmotif in this collection, this is it! Derrida first suggested the formulation in a notebook in 1976 where he had stated of himself that he was 'the last and the least of the Jews [*le dernier des Juifs*]' (13), a construct he riffed on in *Circumfessions*. Gérard Bensussan's, 'The Last, The Remnant . . .', begins his contribution with a meditation on this radically polysemic phrase. It was a gesture of ' "de facto non-belonging," ' as Derrida put it, 'a negative assertion of self', a critique of exemplarism, an effort to think 'the flaw in all identitarian presence' (37, 38), Bensussan comments. Much of this chapter then takes up an elegant weaving of the connections and disconnections between Rosenzweig and Derrida on identity, time, space, and language. Bensussan throws this reading out as bait hoping Derrida would take the bite: 'I have neither exhausted (far from it) the examination of the relationship between the two thoughts [of Derrida and Rosenzweig]', he writes, 'nor even attempted to follow with any consistency the thread of a Derridean reading of Rosenzweig I have simply wanted to suggest a few remarkable consonances, a few intersections, hoping to provoke questions and renewals — and perhaps the beginnings of a commentary by Derrida himself' (49). But Bensussan's parting thought is the most suggestive for readers of Derrida's autobiographical texts, contending that Derridean autobiography is best understood as 'a genre of philosophy — of philosophical dialogue' that enacts

> contradiction of self with self, which Rousseau describes at the beginning of his *Confessions* . . . It organizes itself on the basis of the multiple resistances of self-exposition, of its ungraspable others, of its 'remnants', which make an autobiography into a heterobiography. The genre thereby

> determined is thus the complete contrary to some memorial recording of self and one's self-same. The Derridean heterobiography is a modality of philosophy. (50)

In her own beautiful, elusive, and enigmatic 'nostalgeria' set under the title, 'This Stranjew Body', Hélène Cixous offers her own heterobiographical take on Derrida. She recounts in disjoined shards Derrida's life as a means to reflect not only on Derrida's Judeities, but her own. Cixous and Derrida share similar trajectories: 'crisscrossed by adversary borders, adversary shores... we received as heritage a memory reddened with a hundred mixed bloods' (53-54). She, too, will address the logic of Derrida's phrase describing himself as 'the last and the least of the Jews'. It was an expression, she indicates, of his being inside out, a '*Juiffrançais en souffrance, en sous-France* [Frenchjew overdue/in suffering, in sub-France]', a 'Frenchphilosojew'. Cixous's idiomatic formulations phonetically and orthographically convey her rendering of Derrida as always already hybrid, alien-nationed, 'that body as stranger. A foreign body like dust in the eye, like a fishbone in the throat' (75). The title of her last entry conveys that Derrida was not alone: 'Frenchphilosojews' like Derrida and Cixous were part of a 'Band of Outsiders'.

They were not only Jews, either, this deconstructive band, since surely Jean-Luc Nancy is a stranjew too, at the very least in his intervention for the conference. His chapter closes the volume. It opens by referencing how the 'last of the Jews' is also certainly 'the first of the Christians', which is the topic of his chapter, titled 'The Judeo-Christian'. The Judeo-Christian is 'a fragile designation', he reminds us. Yet it is 'an imbrication or conjuncture essential to our identity or our thought, even "the most impenetrable abyss that Western thought conceals", as Lyotard wrote of the *trait d'union* [hyphen]' (215). As if we needed to be cajoled, Nancy gives five reasons why the topic merits our attention: (1) it is because this is perhaps *the* 'essential, characteristic of a civilization that will call itself "Western"'; (2) 'it implies... a hyphen drawn between "religion" and "thought"'; (3) 'the name communicates... with that other composite: the Greek-Jew and/or Jew-Greek'; (4) to call attention to the Judeo-Christian is to explore the point that both composes and decomposes, orients and disorients the West; and (5) the hyphen in Judeo-Christian is 'the

schema of *Coincidentia oppositorum*', and thereby perhaps the sign of deconstruction *par excellence*.

If Lyotard focused on reading Paul's epistles in *The Hyphen*, Nancy's interpretation of the 'Judeo-Christian' takes the form of a close reading of 'the epistle attributed to James' (218). We should bear in mind that James of the Epistle is Jacques in the French version of the Gospels. Nancy insists that in James the economy of salvation is not Christocentric. For James maintains that 'without works faith by itself is dead'. Nancy even claims that 'faith here exists only in the works' (224), which means that 'faith is not of the order of belief' (225); 'faith is not argumentative; it is the performative of the commandment'. How very Jewish! But what is certainly Christian in James 'is his mention of Jesus' (229). Though even here Nancy will insist that James does not render Jesus as 'sacrifice, or tragedy, or resurrection', which constitute 'Christianity in its most elaborate form' (233). Nancy's deconstructive reading of James serves then to show how faith might 'start composing a decomposition of religion ... [calling for] a day that would be neither Jewish, nor Christian, nor Muslim — but rather like a trace or hyphen drawn to set space between every union, to untie every religion from itself' (233).

Beyond the compelling intercessions of Derrida, Cixous, and Nancy, there are too many interesting chapters to describe in toto, some that deal centrally with the theme of Judeities, some that only do so peripherally: Michal Ben Naftali writes on friendship; Moshe Idel wonderfully illuminates the parallels between Kabbalah and deconstruction; Gianni Vattimo addresses the question of historicity and deconstruction; Joseph Cohen and Raphael Zagury-Orly mull over faithfulness; and Hent de Vries ponders Paul Celan and 'the Shibboleth Effect'. We are also enticed by the dazzling contribution of Jürgen Habermas, who in just over twenty pages is able to offer an overview of the question of ethics in Kierkegaard, Jaspers, Sartre, Adorno and Heidegger, ending his paper with one of the few direct questions put to Derrida: 'Can Derrida leave the normative connotation of the uncertain "arrival" of an indefinite "event" as vague and indeterminate as Heidegger does?' (154). It is Habermas' way of asking the question of what separates Heidegger and Derrida. But he answers the question he asked as well: 'I suspect that we face, here, a division between a neo-pagan betrayal of, and an ethical

loyalty to, the monotheistic heritage' (144). That division of the pagan and the religious, the Jewish ripped apart from the Christian (and Muslim), the Greek from the Jew, the Same/Self from Other, identity from difference are the bifurcations that Derrida always insisted that we question. In *Judeities* we are treated to a fertile set of responses on how to think and rethink and unthink these dichotomies.

DOI: 10.3366/E0305149810000805

Notes

[1] Perplexed by the issue of the spelling of the term Judeities/judeities, as well as its cognates, most importantly Jew/jew and Jewish/jewish, I wrote to Gil Anidjar, the translator of 'Abraham, the Other', who explained that he addressed this crucial matter in a footnote that apparently was not included in the volume. Anidjar notes: 'As Derrida will discuss later on, the French language may present a particular challenge here in that the phrase "être juif" (which Derrida will also render in a hyphenated form) could be translated in a variety of ways, each of which would miss something of the possibilities raised by "être juif": "being Jewish", for example, could imply that one's entire being is Jewish (the adjective — which functions, as Derrida will explain, as an "essential attribute" — here qualifying "my being", as in, perhaps, "my being human". The phrase could however also be translated as "Jewish being" (where the adjective only qualifies "being") and would suggest that one "has" a being — presumably among others — which is Jewish (what Derrida later on refers to as a "secondary attribute"), as in, for example, my "working or professional being" which only describes one, somehow contained, facet of one's existence. One could plausibly illustrate or interrogate the distinctions here raised along the lines of "being human" versus "being a man" or even "being manly" versus "being a man". A difference that finds its origins in the philosophical distinction between essence and accident is marked by English at the level of syntax ("being Jewish" versus "Jewish being") while remaining undecidable in the French. This undecidability is, moreover, reproduced in a situation of oral delivery such as was the case here for Derrida's lecture. Much like the "a" of "différance", the use of lower case (*juif*, Jewish) or upper case (*Juif*, Jew) cannot be heard, and one's essence (*Je suis Juif*, I am a Jew) could be confused for one's accident (*Je suis juif*, I am Jewish). In addition, *je suis Juif* would have to be distinguished from *je suis un Juif* which emphasizes communal belonging. All these distinctions (essence/accident, oral/written, individual/community, *Juif/juif*) have, of course, been interrogated by Derrida himself — as they are here as well. It is doubly important, therefore, to

note how these distinctions are both inscribed and undone here. The purpose of sometimes rendering the word "juif" as — awkwardly enough — lower case "jew" is meant to signify some of the complications attached to these inscriptions and their undoing, to underscore the manner in which Derrida invokes one (most often *juif*) where the other (*Juif*) might have been expected, and the way in which the aural undecidability that lies between *juif* and *Juif* is powerfully put to work in his text.'

Asja Szafreniec, *Beckett, Derrida and the Event of Literature* (Stanford, Stanford University Press, 2007), 264 pp. ISBN: 978-0-8047-5457-4

Lydia Rainford

The prompt for Asja Szafreniec's book is Derrida's avoidance of Beckett, in spite or perhaps because of the apparent proximity of their work. Derrida's most extended discussion of this avoidance, which Szafreneic's introduction quotes in full, was in his famous interview with Derek Attridge, 'This Strange Institution Called Literature', where he said that he found the prospect of responding to Beckett 'too easy and too hard' (2). As Derrida asked, 'How could I write in French in the wake of or "with" someone who does operations on this language which seem to me so strong and so necessary, but which must remain idiomatic? . . . How could I avoid the platitude of a supposed academic metalanguage?' Szafreniec undertakes a book length interrogation of what she calls Derrida's 'unmet challenge' in order to establish the reasons why he felt unable to give a reading of Beckett, and, more ambitiously, to explore how this 'impediment' might 'present itself as a challenge to Derrida's concept of literature' (5).

The first part of the book centres on the incompatibilities between Derrida's and Beckett's concepts of literature. Szafreniec's thesis stems from the way in which Derrida's approach to literature revolves around two contradictory elements: on the one hand, the singularity of any given work; on the other, the fact that each work 'gathers and condenses' in a manner that implies an 'excess of iterability' (31). It is the latter element that underlies what Derrida describes as the economical-juridical 'force' of literature, its ability 'to say everything'

which is simultaneously the movement 'to totalize by formalizing' and 'to break out of prohibitions' (30–32). This conception of literature finds its clearest expression in Joyce's writing, in the 'hypermnesic machine' of *Ulysses* for example, which collects dates, events, languages and even 'traces of the future' in its path (31). However, according to Szafreniec's reading, this same conception is alien to Beckett's work whose preoccupation is with 'unsaying', with repeated tropes of 'exhaustion' and a relinquishing of the mastery that the gesture of 'gathering' might imply. She thus sets up two oppositions, one between Derrida and Beckett and one between Beckett and Joyce, which provide the frame for her readings of Beckett's 'exhaustion' of language, the archive and the subject.

This frame is, of course, rather too clear cut and polarised to account for the complexity of the relation between the writers, and Szafreniec's readings of Beckett and Derrida through the prism of different theoretical traditions (via Barthes, Perloff, Cavell, Deleuze and, a persistent presence, Badiou) serve to complicate this characterization. Her chapter on 'Beckett's "Exhausted" Archives' employs Deleuze's assertion of the 'total exhaustion' of Beckett's writing to counter Derrida's 'gathering', iterable archive, but also allows Derrida's notion of the authorial signature as a 'haunting' to qualify Deleuze's transcendent claims for Beckett as moving towards the 'end of the possible' (107). However, Szafreniec doesn't allow these nuanced moments of reading to deconstruct her initial opposition, and this means that she maintains a rather schematic distance between Beckett and Derrida even when she goes on to explore possible points of transaction between them.

One such point is broached in her chapter on the 'Authority of Literature' through a comparison between the diversions and mirrorings of the narrative of *Molloy* and Derrida's discussion of the 'mystical foundation of authority' in his essay 'Force of Law'. Szafreniec interprets *Molloy* as 'a parable', one which has what Derrida calls a 'philosophical *dunamis*', insofar as it provokes a reflection on 'the phenomenality of the literary medium itself — its law — where the authority of this law is the result of an indefinite iteration' (147–8). This is fruitful ground in terms of her analysis of Beckett's and Derrida's relations to the institution of literature as force and event, but rather than push it further, she turns to Badiou's reading of Beckett's

interrogation and affirmation of the event. While interesting as a phenomenological counterpoint to Derrida, this serves to distract from the foundations she seems to have been building between Beckett and Derrida in this part of the book. The discussion of Badiou also attests to the originality of his insistence on the 'affirmation of the aleatory' in Beckett's work (152). This is an odd assertion given that much recent scholarship on Beckett has emphasised both the affirmatory and aleatory possibilities of Beckett's endless 'going on', and it evades an obvious and important parallel between Beckett, Derrida and Joyce. An acknowledgement of the aleatory is a constitutive part of literature's iterability according to Derrida and, crucially, one of the elements embraced by the Joycean 'gathering': it feeds both the capacity to 'say everything' and the radical contingency and unpredictability which may 'unsay' that 'saying' and bring another repetition.

Szafreniec hints at a more proximate reading of the three writers in her concluding chapter, where she finds in Derrida's late text, 'La Veilleuse', the desire to 'write beyond the instinct of power and mastery. Writing without writing' (189). She weaves it deftly through equivalent double gestures made by Beckett and Joyce until they suddenly become 'accomplices' (191). This welcome but rather belated movement in the book suggests that there may still be other resonances to trace around Derrida's decision to not write on Beckett.

DOI: 10.3366/E0305149810000817

Contributors

Andrew Benjamin teaches Critical Theory and Philosophical Aesthetics at Monash University (Melbourne).

Jacques Derrida was, until his death in 2004, Director d'Études at the École des Hautes Études en Sciences Sociales (Paris).

Ben Grant teaches English at the University of Kent.

Jonathan Judaken teaches History and is Director of the Marcus Orr Center for the Humanities at the University of Memphis.

David Farrell Krell teaches philosophy at DePaul University (Chicago) and at the University of Freiburg.

Elissa Marder teaches French and Comparative Literature at Emory University (Atlanta).

Elaine P. Miller teaches Philosophy at Miami University of Ohio.

Michael Naas teaches Philosophy at DePaul University (Chicago).

Lydia Rainford teaches English at the Open University (UK).

The Oxford Literary Review 32.2 (2010): 303
Edinburgh University Press
DOI: 10.3366/E0305149810000829
© The Oxford Literary Review
www.eupjournals.com/olr